HAUNTED
GREEN BAY

HAUNTED
GREEN BAY

TIMOTHY FREISS

Haunted
America

Published by The History Press
Charleston, SC 29403
www.historypress.net

First published 2010
Second printing 2012
Third printing 2012

Manufactured in the United States

ISBN 978.1.59629.985.6

Library of Congress Cataloging-in-Publication Data

Freiss, Tim.
Haunted Green Bay / Tim Freiss.
p. cm.
Includes bibliographical references (p.).
ISBN 978-1-59629-985-6
1. Ghosts--Wisconsin--Green Bay. 2. Haunted places--Wisconsin--Green Bay. I. Title.
BF1472.U6F76 2010
133.109755'61--dc22
2010033588

I would like to dedicate this book to my wife, Cherri, and to my children—Trevor, McKenna and Evan—who stuck by me through the continuous days and months to get this completed and who gave up their whole summer to let me pursue this adventure. To my daughter, Meredith, whom I wish lived closer and could see more often.

To my parents, Mae and Ken, whom I miss every day.

CONTENTS

CONTENTS

ACKNOWLEDGEMENTS

Heidi Gazza
Dale Johnson
Vickie Patterson
Gail Ives
On Broadway, Inc.
Neville Public Museum
University of Wisconsin–Green Bay
White Pillars Historical Society
Brown County Public Library
McKenna Freiss

INTRODUCTION

In being an honorary part-time member of the SOS (Shadows of Spirits) paranormal investigation team of Green Bay, I am fortunate to have been invited along at times to help the team investigate some pretty cool and historical places. It was during one of these investigations I would have my very first personal paranormal experience. It involved an old 1800s jail located in the neighboring town of Kewaunee, just thirty minutes north of Green Bay. Kewaunee is surrounded by the blue water shores of Lake Michigan and is a hot spot both for tourism and commercial fishermen. It seems that Kewaunee is also a hot spot for ghosts. Many of the buildings in this area have had reports of paranormal activity. The one that I know for sure as being haunted is currently being used as a historical museum but at one time was a jail. My experience happened when I was investigating one of six jail cells. The cell was being used as a display room for tools that were used in the 1800s.

Since I don't have any investigative tools of my own other than a really cheap EMF (electric magnetic field) detector, which I didn't have with me that night, I was given a Maglite miniflashlight—the kind that you turn the handle to operate. These flashlights are often used by paranormal investigators as tools to communicate with a spirit or spirits. How it works is you ask the spirit to either turn on or off the

flashlight in response to yes or no questions. I placed the flashlight down on a display table with it in the off position and began to ask questions to the spirit. The first question I asked was if anyone was with me in the cell. Slowly, but surely, the flashlight began to flicker and then turned on to a solid beam of light. At the same time that this was happening, my head started hurting and I felt a weak feeling coming over me, like my energy was being taken. The feeling subsided and I continued asking questions. Each time my questions were answered, the flashlight turned on and off, while at the same time I would receive the same headache and feeling of weakness. By the end of the investigation it was determined the spirit was a small boy around the age of five. He was possibly connected to the Indian burial ground that was in this area before the jail was built. After the investigation was complete, the historian who let us in the museum that night told us a story of an Indian child's skull and bones that were found when excavating the dirt for the basement of the building. The story reports that the construction workers who unearthed the remains were found kicking and passing the skull back and forth among each another. The bones were then gathered, put in a box and reburied in an unmarked grave somewhere on the property.

Along with many other varied interests, I have also always been a big fan of a good ghost story. My fascination with the paranormal has always been with me since I was a child. But my quest for answers for the unexplained started just eighteen years ago on February 19, 1992. It involved my oldest daughter Meredith and my father who died of cancer.

My father and daughter were very close. They spent many summer evenings together on the back porch talking and also watching old movies on the television while eating their favorite snack, popcorn. She loved her Papa and the feeling was mutual. During the time that my father was bedridden and dying, he would always state how bad he felt that he was unable to spend the time with my daughter like he had done prior to his sickness. He often said to me, "Tell Meredith that I love her and that, when the time comes, Grandpa said good-bye." On the night that he died, he was finally able to deliver the message himself. The night of his death, my daughter—who was four years old at the time—came out of her bedroom saying that Papa was there as a bluish-white light. She

stated that he told her he loved her and told her good-bye just as he had wanted. Now my father was never heard from in that way again, but I know sometimes I can still feel his spirit with us. So whether you are a true believer or not, one thing is for sure—the love of our family carries on even after death.

EARLY HISTORY

The first European explorer who was credited with discovering this great state of Wisconsin was a French man named Jean Nicolet from Quebec, Canada. In 1634, he landed on the shores of Red Banks, which is located on the northern outskirts of modern-day Green Bay. Nicolet was known for always dressing in bright-colored clothing and carrying two pistols with the intent to gain respect from the Indian tribes he would sometimes encounter on his travels.

Nicolet did gain the respect and friendship of the Winnebago tribe that was native to this area. The Winnebagos helped Nicolet in the exploration of the land and Fox River. He would travel the Fox River until it began to widen, which convinced him he had found a passage to the South Sea that led to China. Nicolet returned to Quebec, Canada, to inform the people of his amazing discovery. Of course, it wasn't the South Sea that Nicolet had discovered, but if only he would have traveled just a little bit farther he would have been credited for finding the upper Mississippi as well. Nicolet died by drowning in 1642 on the Sillary River.

One little-known fact about the state of Wisconsin is that it is considered the most haunted state in the nation, and Green Bay certainly has its fair share of spirits that want to stick around. Green Bay is often referred to as a big city with a small-town feel. It is the third-largest city in Wisconsin, right after Milwaukee and our state capital, Madison. When

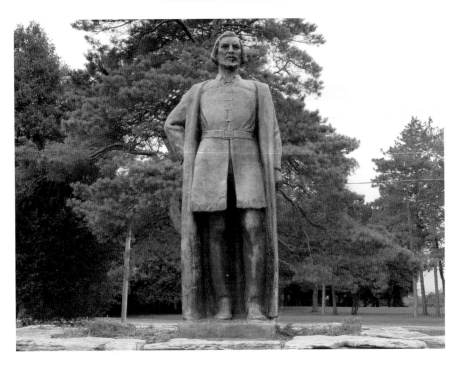

Statue of Jean Nicolet. *Courtesy of Dale Johnson.*

you visit Green Bay, you will notice there are no huge skyscrapers that cut the skyline or a Starbucks on every corner but rather a community that is friendly, generous and one with hometown pride. It is also a town that is steeped in tradition and, of course, football. Green Bay is often called by its nickname, Titletown. This nickname was acquired by the number of Super Bowl titles that the Packers earned. Green Bay has a population of 102,313 and is growing, both in the living and the dead.

Green Bay offers many recreational attractions such as Bay Beach Amusement Park, where guests can ride the rides for $0.25 to $0.50 each. There is also a wildlife sanctuary where you can feed geese and ducks as well as the new zoo where you can see a great variety of animals and even feed a giraffe. And, of course, there is Lambeau Field, home of the Green Bay Packers! Green Bay is a great, family-friendly city, and I am proud to call it my home.

FORT HOWARD GHOST

This story is about the tragic loss of three lives on one cold, Wisconsin winter day. It involves a murder that was considered even colder. The story begins during the mid-1800s, back when Green Bay was actually two separate cities. The west side was the city of Fort Howard, named after the military base that was being used at the time. The east side was the actual city of Green Bay. The two cities merged as one on April 2, 1895, and from what I have read, it wasn't a happy time for the citizens of either city. The merger was thought of more as a takeover and, in fact, the east and west sides of Green Bay still carry a mild rivalry to this day.

Our story actually begins in 1831 at the old Fort Howard military base and involves a young officer by the name of Lieutenant Amos B. Foster; a soldier under his command, Private Patrick Doyle; and a beautiful young local girl, Miss Bailey, whom Foster was engaged to marry. Lieutenant Foster was born in New Hampshire in 1805. He graduated from West Point military academy in 1828 and was stationed at Fort Howard military base in the Fifth Infantry Unit in 1831. Upon his arrival at Fort Howard, Lieutenant Foster noticed one disturbing trend. There seemed to be quite a high intoxication rate among the soldiers stationed at the base. One such soldier was a Private Patrick Doyle. Private Doyle seemed to like his liquor a little too much and it became clear that he was not a fun sort of guy when he was drunk. He became loud and belligerent and

didn't seem to know when enough was enough. Doyle also had a quick temper and that mixed with alcohol was a deadly combination. After experiencing this behavior several times, Lieutenant Foster decided to have Private Doyle arrested and confined for what we would today call drunk and disorderly conduct. While serving his time at the guardhouse, or jail, Doyle convinced the guard on duty one night to escort him over to the officer's quarters where Lieutenant Foster was residing. He said he wanted to discuss the terms of his punishment and possibly negotiate a lighter sentence. The discussion between Foster and Doyle didn't last long before it escalated into a full-blown argument between the two men. It got so out of hand that, rather than calmly talking out a mutual agreement, the argument turned to violence that resulted in the murder of Lieutenant Amos Foster on February 7, 1832. Doyle, blinded by his own anger about not getting some leeway on a shorter sentence, ended up grabbing a rifle from the guard who had escorted him and shot Foster, striking him in the heart and killing him instantly. Private Doyle was tried and convicted of murder in a civilian court and was sentenced to a much harsher punishment than the one he had previously been serving—death by hanging. Doyle was hanged just outside of the Fort Howard walls on October 15, 1832. It was one of only two hangings in the entire history of Wisconsin.

In the aftermath of the murder of Lieutenant Foster, Miss Bailey, having lost her love and hopes for her future, reportedly became violently insane and spent the remainder of her life in mental institutions.

The first sightings of Lieutenant Foster's ghost would come several years later in 1847 when the family of J.C. Delany would occupy the building formerly known as the officer's quarters. Very soon after moving into the building, Mrs. Delany suddenly awakened one night, terrified to find the figure of a man bending over her, watching her while she slept. Mr. Delany thoroughly searched the house for the man she claimed was there, but he found no one. The next day, Mr. and Mrs. Delany talked to some of the soldiers, recounting the story from the previous night about the man in her bedroom. There were still some soldiers stationed at the base that were there when Lieutenant Foster was murdered and they remembered him well. To the surprise of the soldiers, Mrs. Delany gave an exact description of Lieutenant Foster. The most remarkable thing

about her experience was that Mrs. Delany knew nothing about the story of Lieutenant Foster or how he had died. After hearing the story and knowing that the man she saw was no longer among the living, Mrs. Delany ended up seeing Lieutenant Foster two more times in that house. This experience frightened her so much that she refused to continue to live in the house any longer. Due to the story of the ghost, the house stood abandoned until the closing of the base in 1859. All of the buildings were sold off and some were relocated as far away as New Jersey, but most stayed here in Green Bay and are currently located at Heritage Hill State Park. Unfortunately, the officer's quarters had to be destroyed due to lack of care, and that was the end of Lieutenant Foster's ghost.

The military uniform that Lieutenant Foster was wearing on the night of his murder is held today by Neville Public Museum in Green Bay. It still has bloodstains on it and is the only uniform of that time, known as a frock, still in existence today.

GREEN BAY'S HAUNTED PAST

It was a grave discovery. Whenever I pass a cemetery or visit the resting place of my parents, it often makes me truly think of my own mortality and that someday I, too, will experience this same fate. All cemeteries have a spiritual aspect to them, and to address them in any other way would be wrong. They are a place of reflection, remembrance and a connection to the ones we love and miss. Cemeteries are holy places deserving of reverence and respect. It's hard to imagine someone desecrating such an important place as a cemetery, especially over money. Unfortunately that's exactly what took place to one of the oldest-known cemeteries in town—possibly in the state—that was located where Green Bay's downtown district is today.

This area was referred to as La Baye Burial place dating back to the 1740s or possibly even earlier. The name was given by the earliest French settlers, whose bodies, along with Native Americans, now lay under the city streets of Green Bay. The exact location of these burial sites is hard to know. Unlike other cemeteries in the city, this one was abandoned and erased from city maps. Research done through newspaper articles about the discovery of bodies place the cemetery as located under several possible streets. The streets covering this area are from Washington Street to Adams Street and from Crooks Street to Chicago Street. For well over two hundred years until its close in 1838, this cemetery was the burial

place for several family members of the Potawatomie, Menominee, Ojibwa, Ho-Chunk, Miami, Sauk and Fox tribes, along with French nobility who died here during a war in 1733.

The Father of Wisconsin and his father are buried here, along with Kinananotamn, the daughter of the Menominee chief who owned all of this surrounding area. There is also Joseph Leroy, who was the husband of Kinananotamn, and builder of the oldest-standing building in the state, which is currently located at Green Bay's historical state park, Heritage Hill. One of the men involved in desecrating this once spiritual place, solely for the love of money, was a wealthy businessman from New York named John Jacob Astor, who had made his fortune in the fur-trading business. Astor, who owned the American Fur Trade Co., was a shrewd and cunning businessman. He had successfully lobbied Congress to give his company a monopoly on the western fur trade by making it illegal for anyone other than an American citizen to engage in the fur trade on American soil. At this time the American government viewed the local citizens living on their own homelands as foreigners and forbade them to carry on with the main source of local revenue in Wisconsin—the fur trade. The result was predictable.

The other men involved were Arthur Neville, who was mayor of Green Bay at that time; his father J.C. Neville, who was a former mayor of Green Bay; and eleven other prominent wealthy men of the area. Together they built and owned what was known as the Green Bay Water Company, which was later purchased by the city in 1920. The waterworks pumping station was constructed directly on top of the old La Baye cemetery. On October 21, 1886, there was an article written in the local paper about the waterworks grave discovery while digging trenches on Adams Street. It stated that the skulls and other bones found were in a fair state of preservation and pieces of decayed wood indicated that the bodies were in coffins. The bones were discovered less than two feet below the surface, indicating that possibly three to four feet of soil covering the graves had been washed away to the river. A total of fifteen graves were found.

At first the bones were carelessly thrown out of the trench with the earth, but when the news got out, boxes were provided and some of the surrounding residents carefully gathered the remains and placed them into these boxes. The Catholic priests then made sure that these remains

were properly reburied in a nearby cemetery in the town of Allouez. The rest of the remains were left buried in the ground only to be built over with roads and buildings, with not so much as a marker signifying the placement of this sacred cemetery. One of the lingering questions that comes to mind is, whatever happened to the original tombstones that marked the placements of these hidden graves? One theory is that John Astor had them removed and thrown into the Fox River. But after reading the article of 1886 it's more likely they were washed away with the soil into the river. There have been stories told that, every once in a while, some of these tombstones have washed up on the shore badly worn and only recognizable by their tombstonelike shape.

Today there is an organization called the La Baye historical research committee that, along with the mayor's beautification committee, is establishing a trust fund to purchase some of the land on the cemetery site in the hope of setting up a monument listing the names of all the known persons that have been buried there. This desecrated cemetery is believed to be the reason for several haunted buildings located on Washington Street in downtown Green Bay. The first of these building is located at 401 South Washington Street and is currently the South End Bar. Upon arrival at the South End Bar, you can't help but take notice of the unique exterior of this building. Its rustic siding of half-cut logs arranged in diamond-shaped patterns is a stark contrast to the brick and concrete exteriors of the surrounding buildings. When you enter the building, you notice there are no overdone fancy décor, no lighted dance floor and no loud techno music blasting out your eardrums—just an old-time comfortable bar. These are great taverns for just having some drinks after work with your friends or for enjoying a great homemade-style burger.

When I met the couple that currently owns the tavern, they related that most of the poltergeist-type haunting activity takes place either in the kitchen, located at the east end of the bar, or in the hallway storage room. The husband stated that there are a lot of objects in the kitchen that seem to move around on their own, and typically you can hear the sound of plates smashing on the floor. Even though it gets to be a common occurrence, he still gets startled now and then when a plate or knife flies by his head. The wife told of having a terrifying experience involving

the hallway storage room door. She had just gotten back to the tavern from a shopping trip to the store for soda. She propped open the door to the storage room and began grabbing the cases of soda, sliding them through the open doorway. She was in a bent-over position, focusing on the task at hand, when all of a sudden she felt the painful sting of the storage door striking the side of her head and pinning her between the doorjamb and the door. The pressure of the door felt like someone was pushing on it, but she couldn't see who it was. Finally after a few choice words and a "knock it off already," the door pressure let up; she pulled her head out and was ready to start screaming at whoever did this to her, but nobody was there. Now when dealing with the storage room doorway she makes a conscious effort to keep her head and body parts out of the way of a possible slamming door.

The next haunted building is just a few yards north at 403 South Washington Street and is currently vacant but used to be the Glory Days Bar and Grill Restaurant. This business, when it was open, was modeled in Packer football décor. Even the outside at that time was painted in the famed green and gold colors. This establishment not only had a banquet hall that was a favorite spot for wedding receptions and retirement parties—but it also was a favorite spot for poltergeist activity. The employees who worked there reported seeing glasses that moved on their own, dishes that smashed and a general feeling of bad karma. Maybe this is why they ended up closing?

Next stop, Ireland. Located farther north up the street and across at 234 South Washington Street stands a new hotel named St. Brendan's. It is on the same location where the city's bus terminal once stood. St. Brendan is the name of a saint from the 1600s who belonged to the second order of Irish saints, also known as the twelve apostles of Ireland. His influence was widespread both in Ireland and other regions such as Scotland, England, Wales, continental Europe, Germany and along the Baltic coast to the Gulf of Finland. His name even appeared on ocean maps throughout the centuries; during one of his voyages of the Atlantic Ocean, he was believed to have discovered America long before Columbus had. The hotel may be new but it was built in old-time style and charm. It has beautiful dark-stained hardwood wall panels throughout the front lobby and restaurant area, a fireplace in the dining

room and stunning stained-glass windows, specially made in Germany. The stained glass is of a Celtic knot design. The lines of a Celtic knot are interwoven, the meaning being that so are we interwoven with all those around us. We continue on to eternity as others continue on to eternity inexorably wrapped up with all those who join us in this life and the next. Though each loop is individual, each loop cannot be separated from the whole. The meaning of this Celtic design rings true—we are all connected together between both the living and the dead, and that respect for others is most important whether they are above the ground or below it. The elevators and laundry room are the hot spots for the haunting activity here. Employees report that the elevators often like to run up and down between floors by themselves. The doors to the elevators open and close by themselves as well. In the laundry room, there are reports of soap bottles flying off of the shelves and a feeling of not being alone overtakes you.

ENVY NIGHTCLUB

This love story is one to die for. In 1900, Green Bay was growing by leaps and bounds. This small town of fewer than five thousand residents at that time was viewed as an up-and-coming city, with never-ending growth possibilities. This next building played an important part in that growth status. It's currently used as a nightclub, but when it was first built in the summer of 1900 it was known as the Green Bay Theater. It would be the first big-city theater of several to be built here.

The two men who saw the importance and potential of having a theater of this stature built here were Mr. George Johnson and Mr. John Fischer. Mr. Johnson was a traveling theater developer and artist from the windy city of Chicago. He designed the building, and much of his art was used at first to decorate the inside walls. Mr. Fischer was a successful businessman from Kewaunee who would invest the money needed to get this theater built. The cost of construction for this building was $30,000, which back then, of course, was considered a huge amount of money. The impressive architectural features of this new theater would reflect the reasons for the high cost of construction. It was one of the largest theaters built between Milwaukee and Minnesota. It had a seating capacity of twelve hundred people, which in comparison was equivalent to over a quarter of the population of the city living here at that time. The stage was an impressive seventy feet wide by forty feet deep. This theater would

be considered one of the last legitimate nineteenth-century, modern-style theaters to be built in the nation.

George Johnson and John Fischer would sell the building following the first year of operation to a young couple by the names of John and Mary Arthurs. The couple was successful in the operation of the theater but, in 1915, decided to sell it to Dr. John Minihan, who was a prominent surgeon and investor in the area. Dr. Minihan then began leasing the theater building to the national Orpheum Company; the name was changed at this time to the Orpheum and was leased by the company until 1957.

In the year of 1929, competition would move in just around the corner on Washington Street. A new theater was built by Warner Brothers out of California, and it had all the architectural features reflecting the grandeur of that time period. In order to keep up with the new competition in town, the first major remodel of the theater by the Orpheum Company was done. Everything, except the stage and studio areas, was completely redone to the new standard for theaters. The second major remodel of the theater would take place in 1958. This is when the Marcus Corporation began leasing the building and, again, everything except the stage and studios were completely remodeled to the present-day status quo. The name of the theater at this time was also changed to the Vic Theater. This was in honor of Victor McCormick, a direct heir to Dr. John Minihan. In 1986, the theater would become known as the center of performing arts and then the City Center. While under both of those names it was a place where national and local talents were featured.

The biggest change to this onetime prominent theater would come in 1995. The current owner, Dan Hanks, purchased the building and developed it into its present venue—a popular nightclub currently called Envy. Of course, you can imagine this was no small undertaking to say the least. It would require the total removal of the upper balcony and lower general seating as well as leveling the floor from a slant to a flat surface. The stage and studio areas, which are currently being used as storage, have been concealed behind a wall in the back where a second bar is located. The balcony was converted into a plush apartment where the owner lived during the first two years of operation.

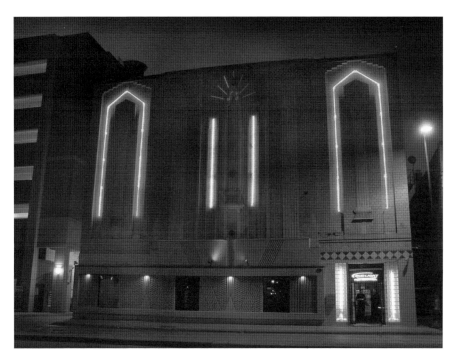

Envy Nightclub. *Courtesy of Dale Johnson.*

That covers the building's history throughout the years; however, the building has an interesting tale that supposedly happened within its very first year of existence. Let's start at the beginning.

Legend has it that in 1900, the first year the Green Bay Theater was in operation, a terrible tragedy occurred. It involved a double murder–suicide that took place just inside the new theater's walls. This story involved a young, beautiful local actress who was performing in the first play ever performed at the theater, *Because She Loved Him So*. This play's title ironically fit with the events that had conspired, not only onstage but off it as well. The young actress, it seems, had fallen deeply in love with the leading man; he, too, had fallen in love with her. Normally, there is nothing wrong with that; however, she was married at the time. Her husband was an extremely controlling and jealous man. He did not take kindly to others having his possessions, and he considered his wife one of those possessions. When he found out that his wife was possibly seeing another man, his anger became more than he could control. At that

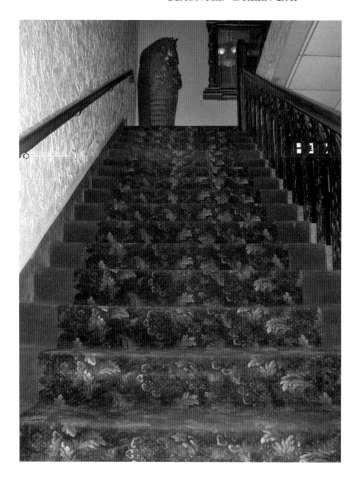

The stairway where the husband killed himself and where his apparition appears. *Courtesy of Dale Johnson.*

moment, he decided the path he was going to take. Consumed by the hate in his heart, he went searching for his wife and her lover. He found the two of them at the place where he suspected—the theater. The two were in the balcony making love when the husband approached. He was furious with what he had seen and knew, in his mind, that there was no turning back. He then pulled a small-caliber pistol from his coat pocket and began shooting his wife where she lay. The wife's lover, stunned and confused, tried to escape by jumping over the balcony rail to the theater's first floor below. Unfortunately, there is no way of outrunning a bullet. He didn't get too far before the husband shot him in the back while he was running away. The husband, now finished with what he had intended to do, started to leave. While halfway down the balcony stairs,

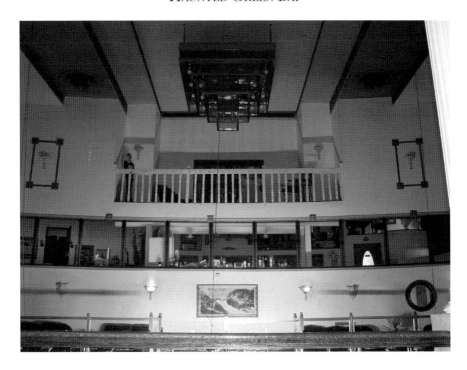

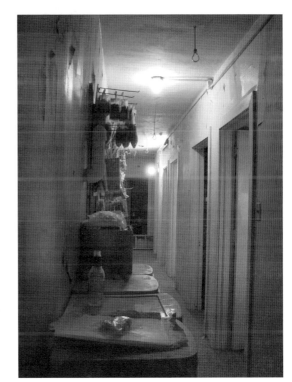

Above: The apparition of the wife's lover jumps off this balcony. *Courtesy of Dale Johnson.*

Right: The studio's hallway where the woman's voice is heard calling people's names. *Courtesy of Dale Johnson.*

he realized the seriousness of the situation. Maybe he became remorseful of the murders he committed, or maybe he simply knew his life was pretty much over and that he would spend the rest of it hiding or in prison. No one really knows the exact reason why, but the husband then took his own life on the stairs.

It seems that after all of these years, the woman's husband and her lover are still reliving their last few moments alive. There have been reports of a shadow figure jumping from the balcony, running and then just disappearing. A few minutes later, another shadow figure comes down the stairs only to get halfway, and then also disappears. As for the wife, no one has seen any figures, but there have been reports of a woman's voice that can be heard calling your name when you are in the back studios.

CAPTAIN'S WALK WINERY

The Captain's Walk Winery is a beautiful example of a home with a traditional Greek-revival style and Italianate details. The home was built between the years of 1856 and 1857 by Elisha Morrow. It is still located at its original location with its original foundation, which is very rare for downtown Green Bay. Many homes have been relocated due to city development. It has a cupola on the top of the building that is meant to represent a miniature version of the house itself. These were often built on the top of mariners' homes and were called Captain's Walks. They were also referred to as widow's walks because so many mariners lost their lives and never returned home. When one visits this establishment, it is easy to picture the house as it was when there was a family living there.

Elisha Morrow was born in 1819 in New Jersey and would end up in Green Bay on November 26, 1840, while herding a hundred head of cattle for the Fort Howard military base. He immediately took a liking to the area and decided to make Green Bay his home. Elisha would have many varied adventures in business and was very politically active in the state constitutional convention. He was an early organizer of the Republican Party of Wisconsin. In 1860, Elisha was one of the delegates for the State of Wisconsin that got Abraham Lincoln nominated as the first Republican candidate for president. Elisha married Josephine Sayre

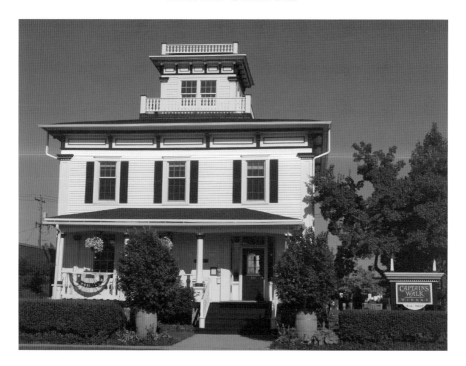

Captain's Walk Winery. *Courtesy of Dale Johnson.*

and, over the coming years, they raised six happy daughters in that house, the second youngest being Helen Morrow. As a young woman she was noted for her beauty, stature, beautiful clothes and unusually attractive red hair. The family shared a good life and loved the house that their father built.

Helen is believed to be the spirit haunting the house. Helen so loved the home she grew up in. She had many happy childhood memories in that house and would eventually inherit the house after her father passed away. Unfortunately, women in those days weren't allowed to work and that put a heavy financial strain on Helen, which resulted in her having to sell the house she so dearly loved. The Green Bay Women's Club bought the house in 1920 for $30,000. Even though Miss Morrow wasn't an active member of the women's club, she did belong to the Antiquarian Society and the Brown County Historical Society.

The Green Bay Women's Club put an addition onto the existing ballroom making it into an auditorium. They held many formal dances

and wedding receptions there until early 1962. The home was then purchased by Mrs. McMahon of Luxemburg and sat vacant for the next eleven years. In the late 1970s, Heritage Hill State Park wanted the house to be moved to its location but it was instead purchased by Mr. and Mrs. Roland Bushmaker and turned into a gift shop. They would end up demolishing the auditorium to make room for a parking lot. Heritage Hill did acquire a lot of the home's furniture and doors that now adorn the Cotton House and Fort Howard Museum. In the 1980s, the house was obtained by Century 21 Realtors and remodeled into commercial space, adding partitioned walls and dropped ceilings. In 1987, the house was again remodeled and occupied by Attorney William Appel. Finally, in 2006, it was purchased by Brad and Eric Schmiling and made into its current business, Captain's Walk Winery, restoring it back to its original beauty.

During the time that the Green Bay Women's Club owned the house, Miss Morrow moved to Boston following the death of her sister, Carrie. She lived there for twenty-seven years, helping her sister's husband, R.H. Pierce, raise her nephew Richard. She would return to Green Bay after Richard was grown and her brother-in-law was dead. She then lived in an apartment at 722 South Monroe Avenue until her death.

Helen was the last surviving member of Green Bay's prominent Morrow family, and she lived to be an amazing ninety years old. She died at 2:45 p.m. on Thursday, February 21, 1952. In August of that same year, she fractured her left hip and arm due to a fall out of bed. Though there wasn't much hope for her recovery, she did survive, but friends noticed a gradual decline in her health from that day forward. Although Helen had come from a wealthy family, sadly she would end up dying almost penniless.

The first reported activity in the house occurred when it was a gift shop under the ownership of the Bushmaker family. The rumor is that a woman was sighted standing at the top of the stairs and then suddenly just disappeared. The Bushmakers also reported a presence that had a negative feeling. They believed this was the spirit of Helen Morrow who was not happy with what had become of her beautiful home. It is thought that Helen remains in the house because of her great love for her family's home and the fact that she always regretted having to sell it.

Later, when the Schmiling brothers purchased the home and were in the process of restoring the property to its original beauty, they also experienced a presence. Upon spending the night in the home, they reported hearing a little girl bouncing a ball, giggling and running around on the second floor. When they investigated, they found no one there, but they did find a faucet turned on in the basement sink. Although they decided not to sleep in the house again, the restorations continued. After the work was completed, the presence—although still felt—seemed more at peace. The Schmilings believed this was because Helen was pleased with the restorations of the house, and the fact that it more closely resembled the house she was so fond of.

Helen still makes her presence known from time to time. For instance, there are reports of faucets in the kitchen turning on by themselves. Also faucets in the basement mysteriously turned on without prompting so often that the owners finally disabled them. In addition, there is an

The room where the book flew off the shelf. *Courtesy of Dale Johnson.*

elevator that is key-operated that will occasionally move from floor to floor on its own. Another incident occurred when one of the former managers jokingly asked Helen for some music and the radio turned on! Helen seems to get particularly provoked with the arrival of new employees and many have experienced her antics.

This location is one that is featured on the Green Bay Ghost Tours tour that I own and facilitate. Minutes prior to the inaugural tour, the manager of Captain's Walk reported the occurrence of strange activity. She explained that guests were sitting at the bar in the winery, when a wineglass came flying out of the dishwasher and smashed into the back bar. The dishwasher was not running at the time. Another incident involved a book that flew off a shelf and shot across an upstairs sitting room. Because this activity was happening right before the tour was about to take place, the manager expressed some concern, noting that if Helen was going to have issues every time a tour came through, that it might not be something they would continue to be part of. The manager and I tried to reassure Helen that we were not trying to exploit her, but rather share the beauty and history of her home with the guests. That seems to have worked because she has been on good behavior for subsequent visits.

THE STORY OF ADELE BRISE

The 1850s were a time of great immigration to Wisconsin. Statehood was just declared in 1848 and land was very affordable. In the summer of 1853, ten families from Belgium settled east of Green Bay. They were the first in a wave of fifteen thousand Belgian immigrants who would soon populate the region. Among them was a young girl by the name of Adele Brise. Her family established a remote farm just northeast of the village of Luxemburg. Adele was born in Dion-Le-Val in the Belgian province of Brabant on January 30, 1831. Despite the loss of one eye as a young child and lack of education, she was described as being known for her charming and inviting personality.

Adele often helped on her family's farm by carrying bundles of wheat several miles to a mill located in a nearby town of Dykesville. She also walked eleven miles following an Indian trail through the woods to church. Her faith was strong and she was a dedicated Christian. While walking to church on Sunday, August 8, 1858, Adele saw a vision of the Virgin Mary. A blinding white light appeared between two trees and overpowered Adele. Paralyzed with fear and awe, she began praying rapidly as the light began to take form. Between the two trees stood the form of beautiful lady clothed entirely in dazzling white garments with a yellow sash around her waist. The lady had auburn hair, deep dark eyes and a radiant kind smile. Adele trembled with fear and the vision gradually faded away.

The next sighting occurred the following week on August 15, 1858, at the same location as before, between the two trees. This time Adele was accompanied by her sister Isabelle and a neighbor. They saw Adele collapse to her knees and start praying. They noticed Adele was looking at someone but they didn't see anything or anyone there. When they arrived at church, Adele confessed her vision to the priest. He advised her that if she were to see the woman again to be courageous and speak the words, "In the name of God, who are you and what do you wish of me?"

Several weeks passed without any sightings. Then on October 9, 1858, the third and last visit from the Virgin Mary took place. Adele was accompanied by her sister and a friend that day. They witnessed Adele dropping to her knees and slowly speaking the words that the priest had advised her to say. Even though her sister and friend could not see the vision, they also dropped to their knees. The apparition said to Adele, "I am the Queen of the Heavens who prays for the conversion of sinners.

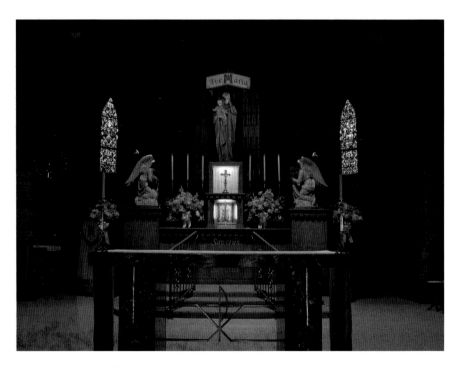

The altar. *Courtesy of Dale Johnson.*

I want you to do the same." She instructed Adele to dedicate herself to teaching the word of God to the people, especially the children. Adele didn't waste any time and eagerly began her mission. She began by delivering the teachings of catechism from house to house. She traveled as much as fifty miles on foot at times. She faced many obstacles, such as inclement weather, severe fatigue, ridicule and the dangers of the forests, but that did not deter her dedication to the fulfillment of the task.

Through the years she raised enough funds to build a chapel, an orphanage and a school. Her father, on the same location the visions took place, built the first chapel. A local farmer donated the land to Adele and a nun named Sister Pauline joined Adele with her mission. She helped run the church and school until the twentieth century. Due to being rejected and ridiculed by the Catholic diocese and skeptics, Adele prayed for divine intervention; miracles soon began to happen. The little chapel seemed to be especially blessed and there were many tales of the blind

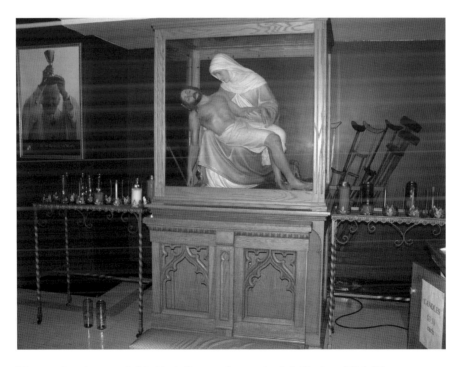

The crutches that were left behind after people were healed. *Courtesy of Dale Johnson.*

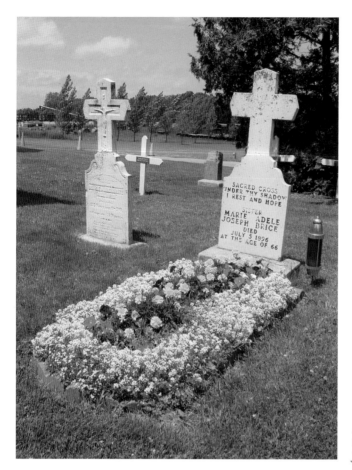

Adele Brise's grave.
Courtesy of Dale Johnson.

regaining sight, the desperately sick being cured and the handicapped being restored to health. To this day a collection of discarded crutches and canes can be seen in the crypt below the church.

One of the most significant miracles that took place was during the great Peshtigo fire on October 9 and 10, 1871. Coincidentally, this was also the anniversary of Adele's third vision. The massive fire would consume more than four hundred square miles of Wisconsin land and took fifteen hundred lives. While the fire was rapidly spreading through the community, many fled to the lake for refuge. Adele and her parishioners stood their ground at the chapel and prayed for divine protection. The fire approached all around the church's fence but did not leap over it. When the fire was finally over, the lonely chapel looked like an island amongst a sea of charred land.

Shrine of Our Lady of Good Help. *Courtesy of Dale Johnson.*

Adele spent her entire life dedicated to the works of religion and charity. She died on July 5, 1896, at the age of sixty-five. Every year thousands flock to the small town of New Franken, once known as Robinsonville, to visit the chapel, pray and learn about Adele Brise's amazing life. There is also a special celebration every year on August 15, the anniversary of the second sighting of the Virgin Mary. We all want to believe in miracles and this story gives us hope that they really do exist.

SOMEWHERE IN TIME ANTIQUES

Sometimes in life we get attached to our possessions and we stay attached even after death. This next story involves a building currently being used as an antique store. It is located at 159 North Broadway and is definitely a fun place to visit. As you enter the store you can smell the intoxicating aroma of freshly popped popcorn that has just been made that day. It is made in one of those old-time popcorn machines, which, in my opinion, make some of the best popcorn ever! There is also an antique eight-ounce glass bottle soda machine with a door that you open and pull out your desired flavor. Everything tastes better from a glass bottle. You can definitely say it is a step back in time. For me, antique stores are wondrous places full of memories that spark one to reminisce of experiences and times gone by. You can find almost anything that you are looking for in these kinds of places; when I glance around and see the items that are placed on shelves, in glass cabinets or hanging on a wall, I can't help but think that some of these things were probably very important to someone's life at one time. In fact, some of these items might have been cherished so much that even in death a person might have a hard time letting them go.

Wait—before I get ahead of myself, first things first—let's start with the history of the building and the company that once owned it. This building originally was built in 1858 as a horse corral for the Fairmont Dairy Plant,

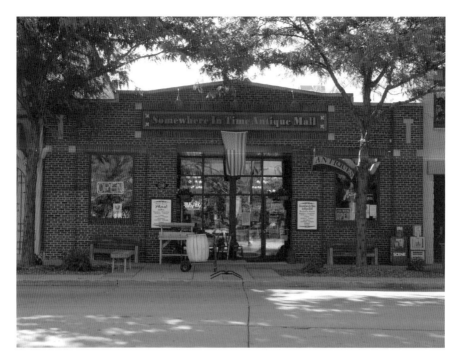

Somewhere in Time Antique Mall. *Courtesy of Dale Johnson.*

which was located across the street. Back then horse and carriage was the mode of travel for both personal transportation and also delivery service. In 1937, the Fairmont Dairy Plant sold off its last horse and started using delivery trucks. At this time the original building that once housed the horses was too small for the new motorized delivery trucks; a front addition was added on. The rafters that were used for the building's roof were retrieved from a hull of a sunken ship found in the Fox River in 1932. So you see, recycling was even important back then! Fairmont Dairy was a national chain of dairy plants, but they were mostly located in the Midwest.

In their heyday they had twenty operating plants in twenty different states. Today none are left as they were all either bought out by other dairy plants or just closed down. The one in Green Bay was originally located in the town of Howard but the horse corral was located on Broadway Street. Around the 1920s Fairmont Dairy purchased a three-building complex on Broadway just across the street from their horse corral. These buildings were already being used as a dairy plant by the

Green Bay Ice Cream and Dairy Company, and it was a logical move. Beneath the street was a tunnel that connected all three buildings together. This tunnel was used for both steam and refrigeration lines and also for freight carts that carried supplies needed to be brought back and forth among the three plants. The main plant was five stories high and had a huge 20-foot-high by 12-foot-wide plywood milk bottle attached to its roof. This bottle could be seen from just about anywhere in the city and surrounding areas. This bottle was part of a water holding tank that stored all of the water used for all three plants. The stored water came from a well that was 850 feet deep that pumped water directly into that tank. Then from this tank the water was dispersed to all three plants. The bottle was regarded as a landmark, and travelers that were coming to Green Bay by train recognized the town by that huge milk bottle.

Fairmont Dairy was very well-known for its high-quality dairy products, one of them being its highly desired ice cream. The dairy plant had its own ice cream parlor that was definitely a family favorite among the people living here as well as tourists visiting the area. Along with their ice cream, the company was also well-known among the Jewish community for their sweet butter. This is butter made without any salt added, and a lot of orders for this product came from the state of New York. Fairmont Dairy also was innovative by trying its luck in many different types of business ventures. One was the selling of live chickens and turkeys. I guess back then people butchered their own poultry. During this time period, Fairmont would use the second floor of the main plant for storage of these birds. One night the turkeys somehow got out and were found roosting in the surrounding trees on Broadway Street. The last in Fairmont's business ideas was the selling of fresh farm eggs. A representative from the plant would travel to the neighboring farms, collect the eggs, bring them back to the plant and then the eggs would be candled. This was a process where a man in a darkened room takes an egg, shines a candle or light behind it and determines whether the egg is good or rotten. Fairmont stayed in the egg business until 1953. Although this was two years longer than they wanted, they did so because of their loyalty to the man employed who did the candling and the fact that he couldn't retire until that time. Fairmont Dairy was sold in the 1980s to Kemps Dairy out of Minneapolis, Minnesota. Kemps ran the

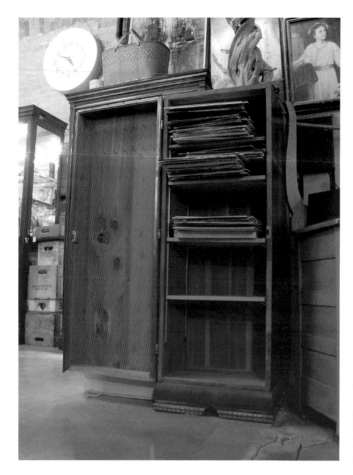

The hope chest that opens at Somewhere in Time Antique Mall. *Courtesy of Dale Johnson.*

dairy for a few short years and decided to shut it down because it wasn't economically feasible to keep it running.

When Dave, the current owner, purchased the old Fairmont Dairy garage in 2000, he completely gutted out the inside of the building. He removed any existing walls except for a small room that was possibly used for storage—now it is the bathroom. He also added a concrete floor to the back half of the building since this section still had a dirt floor. Upon excavating the ground for the new floor, Dave made an interesting discovery. He unearthed a house just a few feet under the ground's surface. He also found everything that a house would need to make it a home. There were forks, plates, glasses, knickknacks—everything you can imagine simply left behind.

It seems that Dave may not only have unearthed the house on that fateful day but possibly the spirits of the owners as well. There have been reports of seeing an elderly couple in Victorian dress that walk the aisle of that back building. Now normally that wouldn't be an unusual sight (except for maybe the clothing) but the couple seem to be floating instead of walking and appear somewhat transparent. Although the spirits seem quite friendly in nature, many vendors complain of being startled when the couple show themselves unexpectedly. They also complain—and blame—the couple for misplaced or missing items in their booths. The vendors have experienced setting something down, turning away briefly and then turning back only to have the item gone, and there's no one else around that could have moved it.

Another occurrence that takes place involves an antique cedar hope chest that has been converted into an album-holding cabinet (this chest sits on its side and has shelves that have been installed vertically for placement of the albums). Every evening at closing time, the owner, Dave, would close the lid to the cedar chest before he went home for the night. The next day when he returned the lid would somehow be wide open. At first, he thought that maybe he hadn't shut the lid tightly when leaving, so he then made sure that when he shut the lid he heard the click of the brass lock. But to no avail, when he returned the next day the lid would be wide open. Dave even went as far as blocking the lid with other heavy objects, but again the lid would open. He finally gave up and now simply leaves the lid open.

TITLETOWN BREWERY

This next story involves the haunting of a business that today is known as Titletown Brewery, but was originally a railroad depot. The building was designed by architect Charles Frost, who was well-known in the Chicago area and was credited for Chicago's Navy Pier and another Green Bay railroad depot. This particular building was designed in Romanesque-revival style. It was built in 1898 and was Chicago & North Western railroad's second-largest depot in the state. By midcentury, as many as twenty-four trains arrived and departed the depot daily. It boasts a massive canopy and a five-story clock tower, which makes it quite impressive. Its size and decoration conveyed the railroad's importance and the city's stature. The ticket office was centrally located and flanked by two waiting rooms. The south-end waiting room was the larger of the two and was for the gentlemen passengers. It featured a large elaborate fireplace; the north end, of course, was for the ladies, smaller in size and had a smaller fireplace. Farther north of the building was a lunch counter for quick meals between trains. Baggage depot and employee facilities occupied the rest. A second-floor clubhouse was reportedly the best in the C&NW system. This clubhouse was enjoyed by many of the well-to-do passengers. Of course over time, progress would be made in auto travel, and, on April 30, 1971, the C&NW discontinued passenger service. This caused the building to sit vacant until 1995. At that time,

the city of Green Bay came to an agreement with the Titletown Brewing Company to buy and renovate the depot. The ladies' waiting room is where the kitchen for the restaurant is and the gentlemen's waiting room is now the dining and bar area.

The depot has quite an interesting history going all the way back to June of 1917. The field artillery batteries left here for Europe to fight in World War I; in May of 1919, the troops returned. In 1929, twenty-thousand fans greeted the Packers after they won the first NFL championship. Also, in 1929, the movie *Thunder*, starring Lon Chaney, was filmed at the depot. Incidentally, Lon Chaney died of complications from walking pneumonia and throat cancer shortly after filming. On August 9, 1934, President Roosevelt visited Green Bay. In the 1940s, World War II soldiers departed and, a decade later, soldiers were again sent off to fight the Korean War. There were also many famous faces that visited this historic depot. Nat King Cole made an appearance in 1950, and, in 1959, Buddy Holly, Ritchie Valens and the Big Bopper came to Green Bay for a concert event called the Winter Dance Party Tour. This was the second-to-last tour stop for the three that would perish in a plane crash on the way to Minnesota. In 1960, again the boys were called off to war. Around the time of the Vietnam War, passenger traffic really started to diminish. This marked the beginning of the end of travel by train.

Many of the original items from the depot were salvaged and reused when the depot was restored for Titletown Brewery. The 1927 freight bill cabinet is displayed as the upstairs back bar. The message board that was used for telegraph message notices in the early 1900s is now used as the upstairs bar beer sign. The stationmaster's track mirror used to spot southbound trains approaching the depot can be seen from the top landing of the main stairwell. The original clock face was removed in 1982 and now hangs in the upstairs pool lounge.

No one seems to know why the depot is haunted, but many of the staff have reported seeing a gray lady that walks the dining area. She is seen wearing early 1900s clothing that includes a gray bonnet and a gray dress and carrying a gray umbrella. She is reported being seen later in the evening usually by the night managers who are closing the place for the night. She is seen mostly floating around in the dining room but is not limited to just that area. No one seems to know who she is or why she is

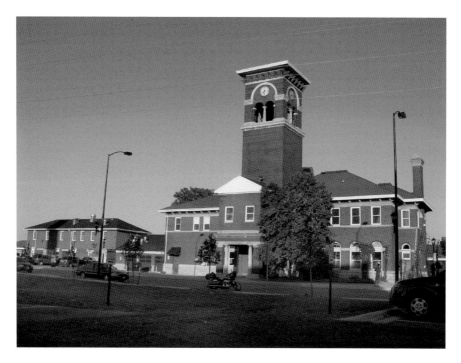

Titletown Brewery. *Courtesy of Dale Johnson.*

there, but maybe she is just one of the many women who became a widow from the thousands of soldiers who lost their lives and didn't return home from the war. Maybe this was a special place for her in life, a place full of happy memories of days traveled. Either way she has currently been accepted by most of the employees that work there now, but for a while Titletown did have a problem with keeping a night manager.

NATIONAL RAILROAD MUSEUM

The National Railroad Museum of Green Bay is definitely what I consider a must-see attraction in the area. It dates back to 1956 when local citizens advanced the idea for a national museum dedicated to the history of American railroads. The museum is a privately funded educational organization that is dedicated to teaching the history and importance of railroading and its significance to American life. The museum started with humble beginnings as an effort to obtain one single steam locomotive for a city park and has now become one of the largest rail museums in the nation. It sees over seventy-five thousand visitors annually and employs twelve paid and over one hundred unpaid staff members. It took nearly four years to acquire the first steam engine, number 261. The arrival of the engine took place on March 10, 1958. Since that day, the museum has acquired quite a collection of both steam and electric engines along with many different passenger cars. The one passenger car that is thought to be haunted was used by General Dwight D. Eisenhower on missions during World War II. Before we continue with this, however, I would like to share a quick history lesson on Dwight D. Eisenhower.

He was born Denison, Texas, on October 14, 1890, as David Dwight Eisenhower. He was the third of seven boys born to his parents, David John Eisenhower and Ida Elizabeth Stover. The family moved to Abilene,

Kansas, where he grew up and graduated from Abilene High School in 1909. Most of the time, Eisenhower was called by his middle name Dwight and, eventually, he decided to permanently change the order of the names. His father, David Eisenhower, was a college-educated engineer but had trouble making a living; the family was poor.

After graduation, Dwight was employed as a night foreman at the Belle Spring Creamery. He worked for two years in support of his brother Edger's college education. With a friend's encouragement, Dwight applied for the naval academy. He passed the entrance exam but was denied admission due to his age. In 1911, on the recommendation of Kansas senator Joseph L. Briston, Dwight enrolled at the West Point military academy in New York. He excelled in the school and, in 1915, graduated in the upper half of his class. The class of 1915 was called the Class the Stars Fell On because fifty-nine classmates eventually became generals. Dwight tried out for the West Point baseball team but didn't make the cut. He later said that was one of the greatest disappointments of his life. Dwight did make the football team and was a varsity starter as running back and linebacker in 1912.

After graduating from West Point, Dwight served with the infantry unit until 1918 at various camps in Texas and Georgia. Eisenhower became the third leader of the new tank corps and rose to temporary lieutenant colonel during World War I. Dwight and the tank crew never saw combat, and, after the war ended, Eisenhower was reverted back to his regular rank of captain but then was promoted to major a few days later. During the peacetime years, Eisenhower's army career became stagnant and a lot of his friends resigned for high-paying business jobs, but he decided to stick it out. Eisenhower then served as chief military aide to General Douglas MacArthur until 1935. Dwight was stationed in the Philippines where he served as military advisor to the Philippine government. He would serve in this position until he returned home in 1939. After sixteen years of being a major, he was promoted to lieutenant colonel, and, on October 3, 1941, became brigadier general. After the attack on Pearl Harbor by the Japanese, Eisenhower was assigned the responsibilities for creating the major war plans to defeat Japan and Germany. During World War II, Eisenhower showed his great talents for leadership and diplomacy. Even though he never saw action himself, he won the respect of frontline commanders.

Eisenhower retired from active service on May 31, 1952. He then ran for presidency in 1953, with his slogan "I Like Ike." He won the election and was president for two terms. He was the first president to be constitutionally forced from office having served the maximum two terms allowed by the Twenty-second Amendment of the Constitution. Eisenhower married Mamie Geneva Doud on July 1, 1916. The couple had two sons, Doud Dwight and John Sheldon Doud. Doud Dwight was born on September 24, 1917, and died of scarlet fever on January 2, 1921, at the age of three. Their second son was born the following year on August 3, 1922. John served in the United States Army, retired as a brigadier general, became an author and served as U.S. ambassador to Belgium from 1969 to 1971. John coincidentally, graduated from West Point on D day on June 6, 1944.

During World War II, Eisenhower was assigned a command train—code named Alive when in use—for all of his military missions in Europe. This command train would pull one of two specially modified British Pullman passenger sleeping cars that were used specifically for his military missions. The names given to these specialty cars were Bayonet and Bayonet II, and which car was used depended on the mission. Bayonet had its first three compartment rooms removed to make one large room. This room then was used both as an office for Eisenhower and for entertaining important dinner guests like the president. It was furnished with just a desk and a large conference table. This passenger car was constantly modified and never changed back to a regular sleeping car. Bayonet II would be modified only upon request. It stayed in service as a passenger sleeping car for some time after the war ended.

Both Bayonet and Bayonet II arrived at the National Railroad Museum in 1968. The two Eisenhower passenger cars were displayed outside and left open for the public to walk through. Of course you can imagine the amount of dirt that was being tracked through and the constant vacuuming that had to be done on a daily basis. In the early 1970s, in order to help preserve and maintain the condition of the two cars, they were moved inside the McCormick Pavilion and are no longer open to the public to walk through. Cleaning of the two trains is completed by volunteers who help out through the year as needed.

One of these volunteers reported an experience that is still unexplainable. He was cleaning out Bayonet II and was just about

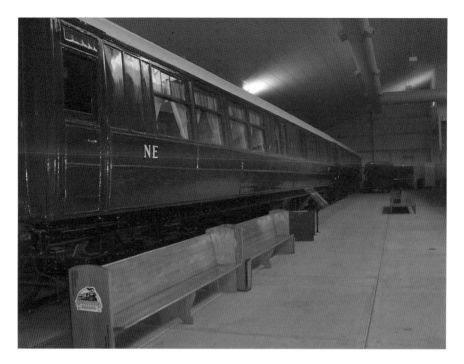

The Bayonet II, located at the National Railroad Museum. *Courtesy of the author.*

finished vacuuming the carpet in the long hallway that runs the duration of the car when he noticed it was time for lunch. He decided to leave the vacuum cleaner plugged in and finish the job when he returned. He locked the entry door to the car and put the key in his pocket. When he returned from lunch he unlocked the door, entered the passenger car and was puzzled by what he saw next. The vacuum cleaner's power cord had been unplugged and rolled up. In addition, the vacuum cleaner had been moved all the way down to the other side of the hallway. The track marks that were made by the vacuum cleaner were no longer visible on the carpet. This may not seem significant, but there is a little known fact about Eisenhower—he strongly disliked having track marks in his carpet and would often hand brush them out after vacuuming. The volunteer asked if anyone else had been in the car and if he had finished the work for him. He was told that no one else had entered the car. Later, he found out that there is only one key for that lock and he had it with him when he left for lunch that day.

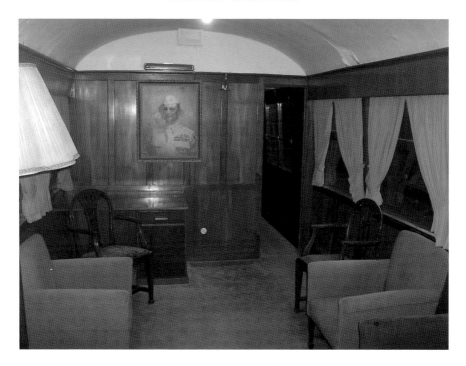

The inside of Bayonet II where the haunting occurs. *Courtesy of the author.*

It has also been said that the land the railroad museum stands on is haunted. While conducting a ghost tour, I met a lady who told me of her ghostly experience as a customer of the museum. The incident occurred in the ladies' restroom. She had walked into the bathroom and was headed toward the stall when she heard the faucet go on behind her. She turned around and saw that no one was there, so she went over and shut off the water. As she was heading back toward the stall, the water turned back on—but this time not in the same sink as before. She felt an overwhelming, eerie feeling come over her, like she wasn't alone in the bathroom, and that's when she ran out in fear. Maybe there is something to what she experienced, for every year during Halloween an organization called Terror on the Fox sets up a haunted house on the museum's land. It has been rumored that they picked this location because of the land being haunted. It is not known why the land is haunted; however, there is suspicion that at one time it was an Indian burial site.

UNION HOTEL

Sometimes we can all use a little help from our relatives, even if they are not alive. This story involves the Union Hotel, which is located at 200 North Broadway Street in DePere. The present Union Hotel was built on the same location as the original Union Hotel, which was moved to another part of town. The hotel would get its name due to its Civil War roots. It served as a boardinghouse for Civil War soldiers returning back home. The new Union Hotel would be built in four different stages. The first part was built in 1883; the next addition was in 1885; the third floor was added in 1903; and the last section was added in 1920. It is the oldest, continually running hotel and restaurant in the state and the first to have air conditioning in the area. It still has the original horse barn and hayloft located behind the hotel, which are used today as the garage and storage area. In the hotel lobby, you will notice one of the last old-time wooden phone booths. The telephone company gave it to the hotel and it is still in its original location. Most phone booths of that time were taken back or disposed of.

The hotel has played a part in Green Bay's sports history as well. The Green Bay Packers's equipment manager, Gerald Braisher, lived upstairs for forty-five years and was the man who designed the *G* logo on the Packers's helmets. Gerald's former room is decorated in Green Bay Packers theme in dedication to him.

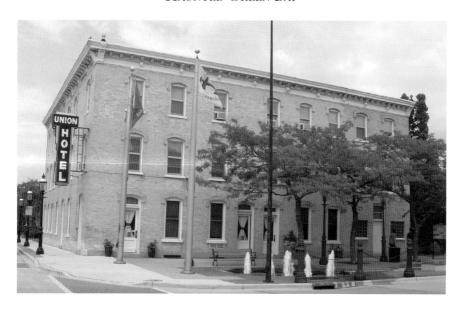

The Union Hotel. *Courtesy of Dale Johnson.*

From the outside the building is quite plain in appearance but once you enter it feels like a step back in time. The last significant remodel of the front dining area was in the 1930s. It captures the rich feel of that era. It adorns beautiful hardwoods and an art deco-style bar and booths. The end of Prohibition was the inspiration for that remodel. There are also several tables in the front dining room that date back to the year that the hotel opened in 1883. The original owner was Nic Altmayer, whose grandson Arthur would graduate from DePere High School in 1912. Arthur is famous for creating the Social Security Administration, and, in his honor, the headquarters for the SSA in Baltimore, Maryland, is named after him.

In 1918, when the Boyd family purchased the hotel, they occupied several of the rooms due to having a large family of twelve children. The current owners are the fourth generation of the Boyd family, and the fifth generation is already working in the kitchen.

The one who seems to be haunting the hotel is the great-grandmother, Miss Antonia Maternoweski. She was born on August 15, 1872, and died in her room on September 16, 1937, of natural causes. She had lived at the hotel for over sixty-five years of her life.

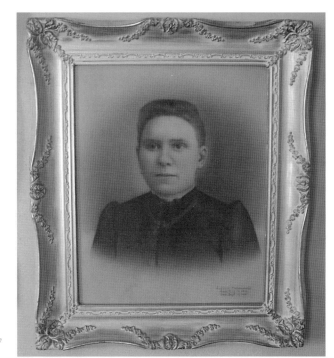

Right: Picture of the great-grandma who is haunting the Union Hotel. *Courtesy of the author.*

Below: The bedroom where the great-grandma died. *Courtesy of the author.*

One of the haunting occurrences that would take place involves one of the current owners, McKim Boyd. One night around 3:00 a.m. while taking inventory in the basement, McKim experienced something quite unusual. The light bulb in the beer cooler that he was in suddenly blew out. He then proceeded into the next section of the basement when that light bulb blew out as well. The next room—the same thing—and also the next. Each light is on a different circuit so it couldn't be explained by an electrical surge in the power line. At this time, the hair on McKim's neck was standing straight up and he sensed it was time to leave. McKim's sister and co-owner, Mary, would also have her own paranormal experience to report. She had just entered the bar area to retrieve a beer for a customer who was sitting in the other dining room area. At first from the angle she was at she thought she was just looking at the normal bartender but soon realized she was dead wrong. Mary noticed that this bartender was semitransparent and floating about a foot off the ground. She started to scream, at which time the apparition turned and just disappeared. Other reports include employees that often have the feeling of being watched even when there seems to be no one else around. The places where the activity seems to occur most are in the bar, front dining area and the basement. Of course the apparition is considered nonthreatening because it's believed to be the great-grandma and that she is just there to watch over her former business and home.

YMCA

The next haunting involves the downtown YMCA, which was unfortunately the location of a double murder of two young men. The construction of the YMCA began on April 15, 1924, and was finished the following year in September 1925. The architectural design is that of a rugged Gothic-style structure and a lot of the stones that were used were dredged from the shores of Green Bay. During the fundraising, they had amassed $575, 393.31, and $426,000 was raised in a one-week span. A total of 4,109 citizens contributed to the project; in its day it was considered one of the finest and most costly buildings of its kind in the nation.

The murders took place on Saturday, August 8, 1987, slightly before midnight. It involved three residents of the fifth floor back when the YMCA had a resident program. This program was focused on young men looking for a new start and rent was adjusted according to their pay scale to help them get back on their feet. The resident who committed the murders was Erik Lee Vogliotti. He was described as a bit of a loner and not very well liked by a lot of the other residents who lived there. He ended up shooting two other residents, the first being Charles Conrad, who was twenty-five years old at the time, and his friend Thomas Mason, who was just twenty-two years old. The shooting happened over a confrontation that had taken place the night prior on Friday, August 7. It seems that

YMCA. *Courtesy of Dale Johnson.*

the two friends, Mason and Conrad, came home after a hard night of drinking. They spotted Erik sitting on the couch in the TV lounge. To give a little background, Erik had been living at the YMCA for nearly a month and had not yet found employment. The YMCA's rules were you needed to find employment within two weeks of moving in so you could start paying some rent. It seems Erik was college educated and didn't want to take a job that he thought was beneath him, so he was waiting it out. This bothered Conrad and, on that night, fueled with some liquid courage, he was going to let Erik know it. According to witnesses, Conrad really let loose and told Erik exactly what he thought. He cursed him out in front of fellow residents, causing Erik embarrassment and anger. Erik decided to stay quiet during this rampage, and when asked why he didn't speak up in his own defense, he replied that he was letting the anger build. When Conrad was satisfied that he had made his point, he went to his room to retire for the night. The next morning, on August 8, Conrad woke up remembering what he had said to Erik and figured the alcohol

had gotten the best of him. He decided to seek out Erik to apologize for his actions and any embarrassment he had caused. He knocked on Erik's door, but there was no answer, and upon searching the rest of the common areas he did not find Erik in the building. The night fell once again and the two friends, Conrad and Mason, decided to hit the town. They arrived home just before midnight and found Erik was waiting for them. Erik was not in the mood to talk or listen to any apologies at that point. He pulled out a handgun and first shot Conrad, striking him in the heart and killing him instantly. He then shot Mason in the stomach, who died two hours later at St. Vincent hospital.

Erik, after shooting the two men, went to the first floor and told the front-desk attendant that she should call the police because he just shot two men. He calmly waited for the arrival of the police and was arrested without incidence. He was described as appearing very cold and not at all remorseful. He is currently serving a life sentence in the Wisconsin Correctional System.

Conrad is believed to be the ghost that haunts the fifth floor. Soon after the murders, residents started reporting sightings of Conrad walking around in the hallways and TV room. This may be one of the reasons the resident program ended soon after. Over the years, many employees have reported seeing a figure of a man on the fifth floor. That area is vacant and no longer used by the YMCA, so there is no logical explanation for the sightings. The theory is that Conrad never got to apologize to Erik for his actions the night prior to the murders, so he is still seeking some resolution there. Since Erik is locked up for life and the fifth floor is no longer inhabited, he will be waiting a long time.

BAIRD CREEK

Sometimes death is not only the end of life but also a way of life. Baird Creek Park is located on the far east side of Green Bay. To get there you must go east on University Avenue to Humboldt Road and then go south at the fork in the road. You will continue for one mile to Baird's Creek Parkway and then turn right into the park. The park is a thirty-five-acre parcel of land containing areas of old growth forest and it is also rich in diverse plants, shrubs, trees and animals. In the middle of this land is Baird Creek, which is believed to have been formed by glaciers and, at one time, was probably a lot deeper than its current status. This park is a beautiful place with many varied things to do. There are miles of walking and biking trails throughout the forest, also a Frisbee golf course on the grass-covered hills and valleys. During the winter season the park is a popular spot for sledding on the huge hills that have their own pull ropes that bring you back to the top of the hill. The beautiful, natural setting of the park has always been a family favorite destination for picnics, weddings, birthdays and graduation parties—all things good and wholesome.

Unfortunately when the day is done and the night arrives, there seems to be a darker, evil side that inhabits this peaceful park. Throughout the years there have been rumors, and even some evidence, of satanic rituals being performed in the outlining woods. Recently, statues of the figure

Sign by entrance to Baird Creek Nature and Ski Trail. *Courtesy of the author.*

Santa Muerte have been showing up in the park as well. The word Santa Muerte translates to mean Saint Death and is a symbol prayed to in a cultlike religion practiced in the poverty-stricken areas of Mexico. This religion appears to have migrated over the border into the United States appearing most often in cities that have a larger Mexican population.

The statue of Santa Muerte portrays a woman who appears as a skeleton figure clothed in a long colored robe. The robe completely covers the Santa Muerte figure from head to toe with only the face and hands exposed. This symbolizes how people hide their true selves from the rest of the world. The robe also covers the skeleton figure like flesh covers the bones of the living—both are said to eventually fall away. The color of the robe can vary and with the change in color comes a change in the purpose of what is being prayed for. The white robe is most commonly seen and signifies prayers of loyalty, purity or the cleansing of negative influences in your life. A robe with the color of red signifies prayers of love and passion with a partner and or family.

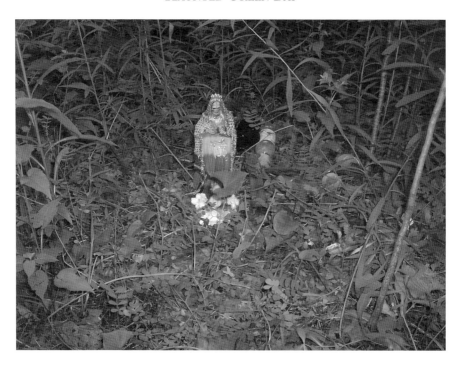

Santa Muerte statue. *Courtesy of the author.*

Red also represents the prayer of emotional stability. The gold-colored robe is for the prayer of economic power, success, money and prosperity. The green robe represents the prayer of unity with your loved ones. An amber or dark yellow-colored robe is for prayers in obtaining good health or money; this particular color robe is commonly used by suffering drug addicts, alcoholics or badly ill people. A black robe signifies the prayer of protection against black magic or sorcery; however, this color is also used for the power to use black magic. Drug traffickers and criminals commonly pray to the black-robed statue. The blue robe represents prayers of wisdom and is commonly used by students or those in the field of education. A robe that is brown signifies the power to evoke spirits from beyond the grave, and finally, the color purple is to open a portal or pathway for the dead.

Candles are also used in ceremonies and are used for a purpose. The specific color of the candle represents the same prayer as the corresponding colors of the robes. For example, a red candle means love,

a white candle means cleansing and so forth. A different color candle and different color robe can be used at the same time during a ceremony, depending on the intent of the individual.

Santa Muerte is usually seen carrying one or more objects. The most common object is a scythe that she holds in her right hand and a globe that is found in her left. The scythe, which is often associated with the grim reaper, symbolizes the moment of death and the long handle means it can reach anywhere. Once used by farmers as a harvesting tool, it also symbolizes hope and prosperity and the cutting of negative energies. In addition, the globe represents death's dominion and a tomb to which we all return. When it is in Santa Muerte's hand it symbolizes her vast power over the world. Other objects that can sometimes appear with the figure of Santa Muerte are a scale that symbolizes justice, impartiality and a divine will and an hourglass that represents time of life on earth and that death is not the end but the beginning of something new. Since an hourglass can be turned to start over, this signifies Santa Muerte's control over time and the two worlds—above and below. If an owl is present with the statue it represents her wisdom and ability to navigate the darkness; the owl is also regarded as a messenger. The last symbol that might be seen with Santa Muerte is a lamp symbolizing her intelligence and spirit that lights the way through the darkness of ignorance and doubt.

Even though some of the ritual practices performed in the cult are similar in comparison to the Catholic religion, the two couldn't be any more different. In the Santa Muerte religion, the statue is prayed to as if she were a living saint. She is considered very powerful by her followers and it is believed that she can perform miracles and grant favors that are not possible by other saints. Some of the favors requested are deviant, or even sexual in nature, and involve such things as damaging property or bringing harm or death to your enemies. Because of these aspects of the religion, the majority of its followers belong to criminal elements in both Mexico and the United States.

In exchange for these favors, or miracles, Santa Muerte requires payment. This payment is given through offerings, which can be anything from cigarettes, candy, liquor or fruit, and are then placed around the base of the statue. If she is denied this payment from an individual she will become angry and cause the death of a close family member. A

follower planning to convert to another religion will also fall upon this same fate.

The Catholic diocese has deemed the religion of Santa Muerte a satanic-based cult and the members as being devil worshipers. Mexican authorities have been trying to hinder the practice of this cult by actively seeking out the placement of these statues and destroying them. Unfortunately, popularity has only increased. It is reported that in the past ten years the religion has grown to over two million followers—and it is still growing.

I believe I can honestly say that I have experienced firsthand the power of this creepy-looking statue. It was at the Baird Creek Park where I was taking pictures of the section of the creek where the spirit of a little girl is often seen standing in the water. As I arrived at the location of the creek, I was surprised to see a beautiful pure white dove standing at the beginning of the trail that I was about to embark on. The white dove

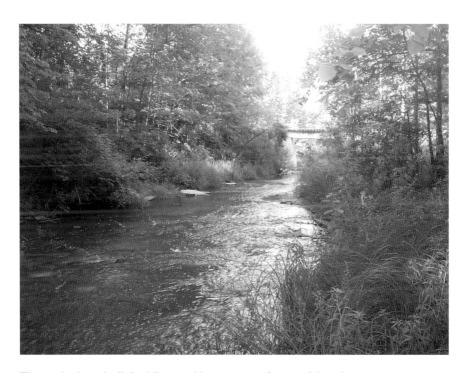

The creek where the little girl's apparition was seen. *Courtesy of the author.*

The trail where the man's apparition was seen walking. *Courtesy of the author.*

is often the symbol used in religion to signify peace and love. The bird stayed in place for quite a while, even as I approached. It was almost as if it was standing guard, warning me of the evil that lurked just ahead on the trail. I continued to walk down this trail taking pictures, still amazed that I was able to see that beautiful bird so close up. Unfortunately, this feeling would soon be replaced with fear as I saw the skeleton statue of Santa Muerte. There were candles placed around it and a broken bottle of liquor was lying in the weeds just behind it. Not knowing what the statue was, I decided to take a picture of it for the purpose of research later. I took the first picture while standing a couple of feet away. Everything worked properly. I then decided to try and take a close up picture of the statue's face, but as I got closer to the statue my camera battery went dead. I backed away and the camera turned back on. I felt this was strange, but thought that maybe I had hit a wrong button or something. I then decided to walk the trail a bit farther and take some more pictures of different locations of the creek. After finishing, I returned to the area of

the trail by the statue and again tried to take a close-up picture of Santa Muerte; again my camera battery died—this time for good. While this in itself was very strange, it was even more disturbing because the batteries had been completely drained of their power and I had just purchased and installed them prior to going to the creek.

I originally went to Baird Creek to take pictures for several different stories. These stories have been around for some time, one involving the ghost of the little girl by the creek. There is another of a man's spirit that supposedly walks the wooded trails. And finally, a story about persons who hear the sounds of children laughing and playing well after dark. Even though these three stories are interesting and worthwhile, it did not prepare me for what I stumbled across. I didn't know who or why these other spirits might be in Baird Creek, but perhaps it has something to do with that creepy statue and the worship of Santa Muerte.

LAWRENCE CEMETERY

This next story involves the haunting of the Lawrence Cemetery, aka Cady Cemetery, which is located just on the outskirts of Green Bay in the small town of Lawrence. The town has a population of 1,548 people and a total land area of only 16 square miles. The cemetery for the town was established in 1858 and is still actively used. Even though the grounds are very well maintained and cared for, some of the oldest tombstones that lie flat to the ground are being grown over by a layer of grass. Some of these tombstones are so bad they have disappeared altogether under the earth.

Both the town and cemetery are named in honor of Amos Adams Lawrence. He was the son of the very wealthy dry-goods merchant Amos Lawrence, who is well-known—among other things—for his many sizeable charitable contributions to universities. Amos Adams Lawrence it seems would follow in his dad's footsteps. He was born in Groton, Massachusetts, on July 31, 1814, and graduated from Harvard University in 1835. Two years later, he started his own countinghouse business. Between the years of 1843 and 1858, he created a partnership and established the firm of Lawrence and Mason. The company was a selling agent for many large textile factories, the main one being Cochero Mills of Dover, New Hampshire. Amos went on to establish a hosiery and knitting mill in Ipswich and was a director in many large companies. Like

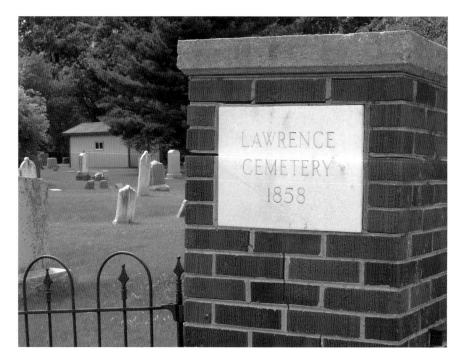

Sign by entrance to Lawrence Cemetery. *Courtesy of Dale Johnson.*

his father, he was very successful and contributed large sums of money to universities and charitable causes, one of them being the colonization to free Africans in Liberia. Amos would come into possession of much land in Wisconsin, primarily as payment from loans he had given to a man by the name Eleazer Williams of Green Bay. One of these plots of land would be donated and used for the college that is named in his honor—Lawrence University—which was built in 1849 (now known as Lawrence College) and is located in Appleton, Wisconsin. He also owned land in the town of Lawrence. Amos died in Nahant, Massachusetts, on the 22nd of August 1886.

There seems to be a wide variety of haunting activity that takes place in the old Lawrence Cemetery and all of it is perceived as evil in nature. One of the reports involves a menacing doglike growling that is heard coming from the far back corners of the cemetery. People wonder, could these be the hounds of hell? On occasion, visitors report being followed by a mysterious greenish-colored fog that floats just above the

The shed where the lights turn on and off. *Courtesy of Dale Johnson.*

ground; however, others have experienced a black shadowy figure that lurks nearby. Both of these strange occurrences always remain within the borders of the cemetery gates.

In addition to the incidents above, some have witnessed unexplainable lights and orbs that float around the cemetery at night. On one occasion, a group of three men saw the cemetery storage shed lights turn on and off on its own. In general, people have said that they have a feeling of uneasiness when at the cemetery. Visitors have reported being physically sick for hours after leaving. The symptoms people claim to have experienced include numbness over half of their bodies, convulsions, neck pain, headaches, nausea, weakness and pain of their internal organs. So remember, the next time you experience any of the above symptoms, it might not be the flu after all, but instead it may be due to the fact that you were just at a haunted location.

THE LORELEI INN

The name says it all. The Lorelei Inn restaurant and pub is home to the most delicious, authentic German cuisine you could ever hope to find. It was built in 1926 and is located at 1412 South Webster Avenue on the east side of Green Bay. It is believed to be the third-oldest consecutive running restaurant in the area, with only two families having owned it. As you enter the Lorelei, it feels as if you have stepped into a pub in Germany. It has several German-crafted clocks and beer signs throughout the pub and also has a beautifully painted mural in the dining room area, which was added in 1950. The picture on the mural portrays the legendary German folklore tale of the woman named Lorelei, whom the restaurant is named after.

The story of Lorelei (also spelled Lorely) has many different versions, but German author Clemens Brentano wrote the original story in 1801. It started as a poem taken from his novel *Oodwi oder das steiweme beielder mutler*. It tells of an enchanting female connected to a rock. In the poem the beautiful Lorelei is falsely accused of maliciously bewitching men and driving them to their ruin. She is later pardoned, and on her way to a nunnery she passes and climbs a huge rock cliff. At this time she begins looking for her unfaithful lover, who has abandoned her for someone else. She slips and falls to her death in the river below. The rock would retain an echo of her moaning sounds as she fell. This rock then became the

Lorelei. Brentano had taken inspiration for the poem from a Roman poet he admired by the name Publius Ovidius Nado who was born on March 20, 43 BC. The Roman poet, known as Ovid in the English speaking world, wrote three poems that were dedicated to slighted women who were in some way mistreated, neglected or abandoned by their lovers. Brentano also was inspired from Greek mythology of a mountain nymph called Echo who loved the sound of her own voice. She had an affair with the Greek god Zeus, in which his wife, Hera, finds out and takes Echo's voice away as punishment.

The Lorelei rock is located on the eastern bank of the Rhine River near the city of St. Goarshausen, Germany. It now soars 120 meters above the waterline, but 600,000 years ago it was at plateau level with the Rhine River. It marks the narrowest part of the river between Switzerland and the North Sea. A very strong current, along with rocks just below the waterline, has caused many fatal boat accidents there. The name Lorelei comes from two words put together. *Lorela*, German for murmuring, and *ley*, Celtic for rock. The translation of the name would therefore be murmur rock or murmuring rock. This name was given to the rock because of the sound of echoes that were heard as a result of the strong current and a small waterfall, which together sounded like murmurs bouncing off the rock. Today, the sound is barely audible due to the urbanization of the area.

The Lorelei restaurant is also home to some legendary tales of its own. It is said that some ghosts have taken up residence there. Two of the ghosts are believed to be mafia-connected. During the years of Prohibition, mobsters ruled many of the taverns, motels and restaurants here and throughout Wisconsin, supplying them with the illegal alcohol beverages so highly desired by patrons. It is believed that the Lorelei was the murder site of two suspected mobsters likely from that era. It's not quite clear the exact location of where the murders took place, whether inside or outside the Lorelei, but the presence of the two men have been felt throughout the bar area and the basement. There is a feeling of a threatening and negative energy. At one time a customer even said she believed she saw one of the spirits standing at the front entrance. She reported seeing a menacing-looking man in a suit standing alone at the doorway, and then he just disappeared.

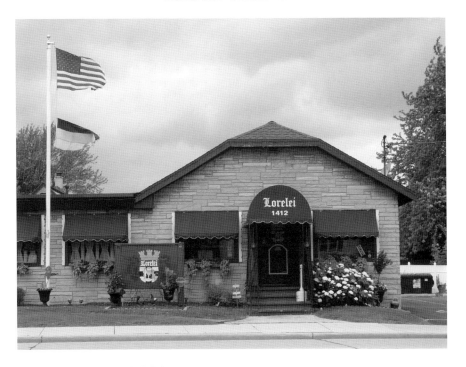

The Lorelei. *Courtesy of Dale Johnson.*

The other presence felt is that of the previous owner, Leonard Hack, who was the father of the brother and sister who run the Lorelei today. Leonard Hack was born in 1929 and died in 2002 from a battle with lung cancer. He married his wife, Marilyn, in 1954. They had four children, including the current owners of the Lorelei—daughter Lynn, who is the oldest, and her brother Pat, who is the youngest—having taken over in 2001. Leonard Hack served in both the Marine Corps and the Coast Guard. After his honorable discharge, he became a traveling engineer building nuclear power plants all over the United States. The traveling was hard on the family, and none of the four kids graduated from the same high school, but they managed to make it work. In 1983, Leonard's traveling days came to a halt when he purchased the Lorelei after being let go from his employer after twenty-five years of service. The wife and kids were at first apprehensive about the new venture that their dad had just embarked upon, but they had faith that everything was going to be all right. Leonard worked hard, along with his family, and made the Lorelei

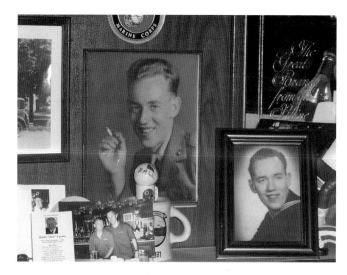

Left: Picture of the owner's dad who is one of the entities who haunt the building. *Courtesy of Dale Johnson.*

Below: The dad's favorite bar stool where his presence is felt. *Courtesy of the author.*

a great family restaurant and a place for a truly great eating experience. Daughter Lynn has felt Leonard's spirit many times throughout the years after his death. His picture hangs near, and his presence can be felt on the bar stool at the end of the bar, which was his favorite place to sit and

The table that is haunted. *Courtesy of the author.*

smoke a cigarette. Sometimes she can smell the smoke from his cigarettes when no one else is around. Leonard is also known to haunt the basement where the office is still located. He is, of course, a positive energy and a protector of the place. Recently, Leonard was credited with driving off one of the negative mob spirits because its presence has not been felt for some time.

There is also a table in the dining room area that is believed to be haunted. It is located in the corner, below a stained-glass octagon window. Customers have been reluctant to sit at that particular table to eat their meals; many who have sat there have reported a strange feeling and have asked to be moved to a different table. Because of this, the owners have now placed a sign on the wall by the table that states, "Beware this table is haunted; sit at your own risk."

REGINA'S SEVEN PILLARS

It only seems fitting that, one who can talk to the dead, would also be haunted by them. This next building located at 1138 West Mason Street was built as a strip mall in the early spring of 1954. During construction, a young man in his twenties died by breaking his neck after falling off the roof. That man's name was Eric and he loved his life as a construction worker. It was on a brisk Friday afternoon, just around quitting time, when Eric would make that fatal mistake that cost him his life. Eric's personal character was described as one of integrity, hard working and he was a highly focused individual. It seems this day Eric was distracted and couldn't keep his mind on the work that needed to be done. He kept daydreaming of the girl he had met earlier that week and the date that was scheduled with her that night. Unfortunately, that date never took place. Eric had just a few more tasks to get done on the roof before he could end his workday and go home. Eric, in his hurried pace, wasn't watching the placement of his feet. He stepped backward right off the roof's edge and fell to his death. Later that evening his lifeless body was found by his employer lying in the back parking lot.

Eric's ghost is just one of the many spirits currently hanging around, haunting the building known as Regina's Seven Pillars. Eric's spirit can be seen walking the hallways and in the rooms of the building, wearing

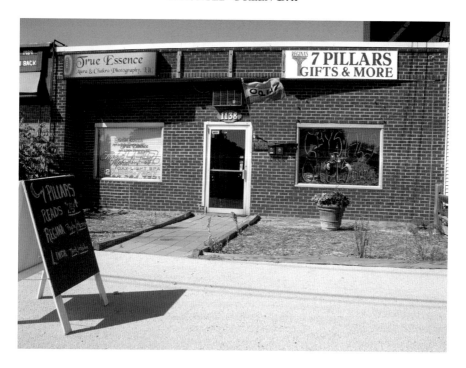

Above: Regina's Seven Pillars. *Courtesy of Dale Johnson.*

Left: The back of the building where Eric fell to his death. *Courtesy of Dale Johnson.*

the clothing that he died in. He is seen wearing a tan canvas work jacket and pants of the same color. Sometimes Eric is seen without any pants— this is because he does not always have his legs with him! Also, when Eric wants his presence to be known, he likes to make the front door's alarm ring. This alarm signifies that the door has been opened. The ringing of the alarm can sometimes be heard several times in one day and no customers are seen either entering or leaving the building. One more thing that Eric likes to do is play with the hair of women. Customers have stated that while there they have felt what is believed to be a large man's hand touching the back of their heads. Regina, the psychic who rents the building, believes Eric's spirit is of a protective nature and is a caretaker of the place.

The next haunting that takes place in the building is by a spirit of a blonde-haired, playful little girl by the name of Anne Marie. She can often be heard laughing, playing and chasing the resident black cat down

Picture of Anne Marie who is one of the apparitions haunting Regina's Seven Pillars. *Courtesy of Dale Johnson.*

the hallway. There is a picture of her that can be seen hanging on the wall in the main waiting area. Anne Marie's spirit seems to be attached to her own picture—anyone who owns it gets Anne Marie along with it. Regina was given the picture after it had been found abandoned and shoved in a corner of a dark and lonely garage. Regina fell in love with the picture instantly and took it to be properly displayed and taken care of. The story of Anne Marie's life is that she tragically died in a fire at the tender age of three.

She lived during the 1800s in her parents' farmhouse, which was located across the lawn just a few yards away from her grandparents' house. She was the pride and joy of her grandma and grandpa and she visited them daily. She often woke up very early in the morning, before her parents, and walked through the dew-soaked grass to their house. One morning she decided to stay home—unfortunately this was the same day fire would consume her parents' old farmhouse. Her mom and dad woke up that morning to the overwhelming smell of thick black smoke. They went to retrieve Anne Marie from her bedroom, but when they entered her room the bed was empty. They assumed she had already left and was safe and sound with the grandparents next door. They were horrified to discover she was not at her grandparents' house. By this time the house was in a total blaze and reentry was impossible. Many hours later when the fire was finally extinguished, they found Anne Marie's badly charred, lifeless body hiding in her bedroom closet. Anne Marie also likes to show her presence by manipulating her picture to smile. A man who is a regular customer at Regina's states that when this happens he gets a little freaked out but he is starting to get used to it.

In addition to Anne Marie's picture, Regina also owns a haunted 1800s gentlemen's dresser. The original owner of the dresser was an elderly man by the name of Gus who died of stomach cancer. Gus wasn't a very pleasant man and a lot of people did not like him. When he was dying, the neighbor who lived next door to him became his primary caretaker. Gus did have a daughter but she lived out of town and was a single mom who worked full time. She could not always be there when Gus needed someone. When Gus died, the daughter, to show her gratitude and appreciation to the neighbor for all of his hard work in helping with her dad, gave him Gus's favorite 1800s gentlemen's dresser. The neighbor

loved the dresser and was very excited to receive it. Not too soon after getting the dresser home that excitement turned to fear. It seems that Gus was not ready to part with his favorite piece of furniture. A few days passed and strange things began to happen. The dresser drawers could be heard opening and closing by themselves. The neighbor would hear the drawers slide out and then the loud bang of the drawers slamming shut. This happened continually both day and night. Soon his nerves were on edge because of the deafening noise that echoed throughout the house. Finally, he had enough; he entered the room where the dresser was and called out to Gus to "knock it off already." The drawers stopped but in the mirror he saw Gus looking at him laughing. At this time he gave the dresser to Regina. Regina performed a cleansing on the dresser,

The haunted dresser. *Courtesy of Dale Johnson.*

which requires the burning of sage. This is a Native American ritual that is used to get rid of menacing spirits. It worked for a while but Gus still shows up now and then, and lets them know he still owns that dresser.

In addition to the resident black cat at Regina's, there's also a ghost of a gray cat that comes and goes at will. It has been seen, but most of the time they just hear it playing with the real cat.

One more entity that was seen only once, at opening time at Regina's, was an early 1800s priest dressed in a long robe and wide brim hat. He was standing in the corner of the waiting room. Regina was startled and asked that if it was of a negative nature to please leave; it never was seen again.

The ghost investigation team of Shadows of Spirits (SOS) conducted an investigation of the building on June 26, 2010. That night the team found two electronic voice phenomena (EVPs), one being of a man's voice saying his name was Eric and the other of a woman saying Reggie. This voice was believed to be Regina's friend who had recently died, not too long before this investigation.

BAY BEACH
AMUSEMENTPARK

Some spirits just like hanging around; and where better to hang around than an amusement park? In the year of 1892, a young entrepreneur by the name of Mitchell Nejedlo started an amusement park in Green Bay known today as Bay Beach. He was attracted to the natural beauty of the area and purchased a small strip of land right on the bay. Mitchell began developing a private beach resort, which he named Bay View Beach. The resort had a dance hall, a bar and a small bathhouse. He had planned to divide the land into individual lots for sale to be used as summer cottage sites. Because most of the land was swampy and heavily infested with mosquitoes, Nejedlo had a hard time attracting visitors. Another cause for problems was that when it rained the road that was used to get in and out of the resort became a huge, impassible mudhole. In 1902, Captain John Cusick became partners with Nejedlo, and, in 1908, he bought out Nejedlo's portion of the resort.

Once Cusick took over complete ownership, he built an impressive 8-foot-wide dock that extended 570 feet into the bay. The dock had a covered 30- by 30-foot pavilion at the end of it. Cusick also purchased a steamboat and began transporting passengers from a dock near the Walnut Street Bridge to the new dock at the resort. Due to the popularity of swimming at the resort, Cusick made a small fortune renting swimsuits. They were rented for $0.10 apiece, and, on a good day, he could bring in

as much as $450.00. Even though the swimsuits were often wet and filled with sand from the prior guests, the customers never seemed to mind or complain. The original pavilion consisted of a center portion that was two stories high and used as the kitchen and dining room area. It also had a west wing that was used as a roller-skating rink and an east wing that was a dance hall. In addition to the roller coaster ride that was built in 1901, Cusick, in 1908, built a ride called Shoot the Chutes. It involved a flat-bottom boat that could hold twelve passengers. The boat would simply slide down a fifty-foot ramp and skim across the water for several yards. The boat was then cranked back up by a winch. The cost was $0.10 per ride. The ride lasted for only two seasons due to the destructive forces of harsh Wisconsin winters and the crushing force of the ice from the bay.

By 1910, Bay View Beach was booming and had become quite popular as a successful tourist stop. In 1911, Frank Murphy and Fred Rahe bought the resort and hired Cusick as the manager. Many new attractions were added at this time, including a merry-go-round, hot air balloon rides, baseball games and nightly dances in the pavilion. In 1916, Cusick left Bay View Beach to work for the Indian Packing Company. Cusick's parting would be the beginning of the end for the success of Bay View Beach.

Due to declining business, in 1920, Murphy and Rahe donated the eleven acres with all of the buildings and attractions to the city. The only stipulation was that it only be used as a park and playground. At this time, the city shortened the name to Bay Beach and purchased additional land for expansion. The city leased out the operation of the park until 1950, at which time the city's park and recreation department took full control. In 1930, swimming was still allowed and a new bathhouse was built, but three short years later in 1933, due to pollution, swimming was banned. People continued to swim there until 1938 despite the dangers.

President Franklin D. Roosevelt visited the park in 1934 as part of the tercentennial celebration. Thousands of people showed up to hear the president speak. The east wing dance hall was the hot spot for teens throughout the ages. During the mid-1940s, dances were offered two nights each week at a cost of fifteen cents per night. Teenagers could divide their time between dancing and roller-skating. By 1972, due to

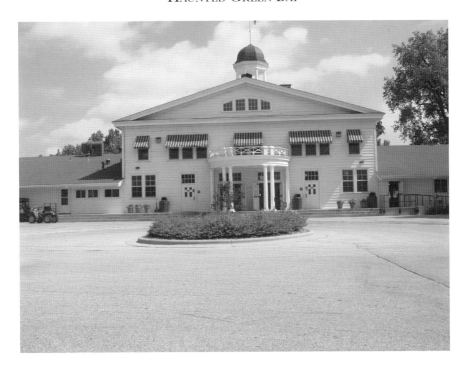

Above: Bay Beach Pavilion. *Courtesy of Dale Johnson.*

Right: The overhang in the pavilion, where the haunting occurs. *Courtesy of Dale Johnson.*

lack of interest, teenage dances had been phased out. The pony rides began in 1931 by Frank Van Bellinger and are currently run by the third generation of that family. The park today has expanded to more than forty-five acres containing sixteen rides, seven shelters, two playgrounds, picnic and softball and volleyball areas. If Mitchell Nejedlo was alive today he probably would be amazed at just how big the place has become.

Throughout the years, the rumor of the main pavilion being haunted was mostly just a legend circulated among the employees that worked there. Every new employee was told the story of the woman who was believed to have been found hanging by her neck from the railing of the second-floor overhang. It's told that she was possibly the lover of one of the previous owners. Due to depression from his rejection after a long love affair, it is said that she took her own life at the park to spite him. Some of the activity reported is of footsteps walking on the upstairs overhang when no one is up there or of a woman's voice that calls your name. Back in the eighties, a manual typewriter would reportedly type by itself.

Bay Beach has been a tradition that families have enjoyed for generations, but the next time you go to Bay Beach for a thrill you might just get it from something other than the rides.

THE GIFT ITSELF

There are two streets in the business districts of Green Bay that I would consider possibly the most haunted in the city. The first one is Washington Street, which is located on the east side of Green Bay's downtown district. This is where an old 1700s Indian–French burial ground was desecrated by thoughtless corporate greed. Many of the buildings in this district have reported frequent poltergeist activity. The second location can be found on the west side of Green Bay in what is known today as the Broadway District. This is in the area where the old Fort Howard military base was located. In fact, just until recently, the old military jail for Fort Howard was located in this area and was being used as a residential rental property. It has currently been moved to the city's historical park, Heritage Hill, where it is going to be restored back to its original condition as an 1800s jail. This would not have been possible without the hardworking, dedicated crew of the nonprofit organization known as On Broadway, Inc. This organization is dedicated to the economic revitalization and historic preservation of the Broadway District. They were the first to find this historical gem and petitioned to have it saved and preserved. In addition, they are responsible—along with the city—for restoring and renewing the historical Broadway Street in the Broadway District.

This street at one time was considered less than desirable, even scary after dark; however, not because of the ghosts that resided here but rather the people that frequented the area. The businesses on this street mostly consisted of run-down taverns and seedy adult bookstores. There was a definite criminal element in this area and it was not a very nice place to visit. The street today has been beautifully revitalized, in a 360-degree turnaround, and is completely different from its once-checkered past. The taverns and bookstores have either been torn down and replaced with new buildings or rehabbed into fun and respectable businesses. As you travel down Broadway Street you can find everything that you are looking for from antiques, jewelry, coffee shops and furniture stores. There is also a wide variety of restaurants to satisfy any appetite.

You will notice one store that stands out more than the rest. This is largely due to its brightly colored exterior paint job—it is pink, turquoise and yellow. This building is located at 125 North Broadway and was built around 1894–1895 by Warren Ringsdorf. It is not certain what business first inhabited that location or even the exact year that they began occupying it. Records show that in 1910, a store by the name of Bungners Furniture was renting the building. Along with the furniture store, which occupied the bottom half of the building, a dentist office was on the second floor. Later the building became many varied things: Wilcox Harness Company, a funeral parlor, a hardware store and sunshine laundries. Then, in the 1960s, the building housed its first bar, Butch and Ma's Tavern. Through the years, a couple different bars would reside there, including Ritter's Tavern and Chris and Dave's Back Again Bar. This was one of many locations that would become bars, and it contributed to the large number of taverns that would populate this part of town.

This badly neglected, run-down building was then sold to the city and scheduled for demolition. The current owners, Al Buch and Michelle Zjala Winter, purchased the building in 1993. They saw potential in this building and saved it from the wrecking ball. Upon remodeling the inside of the building, the current owners found evidence of fires within the walls—possibly as many as thirteen. According to records, there is evidence documenting one of the fires, which took place in 1925. This fire changed the front profile of the building to what it looks like today.

The Gift Itself.
Courtesy of the author.

Because of the fire, the front entrance and display window were rebuilt at an angle and pressed tin ceilings were added. In addition, all of the wood floors were removed, but the building retained its beautiful second-story bowed window. This window was restored, along with the skylights and roof, by Buch and Winter. The building is currently being used to display art and as a custom jewelry shop. The store is over 1,680 square feet with over one hundred artists showcasing their work, including thirty-nine jewelry designers.

The haunting of this building is most often reported as happening in the second-floor hallway, although it is not limited to just that area. The second floor has been converted into an apartment rental. The apartment has a back hallway that leads to stairs that exit the building. The back

hallway is the location where the spirit of a little girl is most often sighted. She is reported to be about six years old, having auburn wavy hair and a white dress. She can often be found just standing there as if waiting for someone to return. Other reports have placed her in both the apartment upstairs and the back room to the gift shop. No one seems to know who she is or why she continues to stay there. Maybe it has something to do with one of the thirteen fires that took place in the building or the funeral home that once was there. I guess we will never really know.

BELLIN BUILDING

This story involves a man who gave so much of his life for the benefit and needs of others. His name was Dr. Julius J. Bellin, and he was a prominent surgeon and physician in the Green Bay area. He was born in the year 1870 and would die at the young age of fifty-eight, having suffered from complications due to several diseases. This, however, would not be the last that we would hear of Dr. Julius Bellin. There are two buildings in Green Bay that bear the Bellin name. The first is a hospital that Dr. Bellin started in 1907. The hospital was originally a fifteen-bedroom house located at 112 North Adams Street and was purchased from Dr. B.C. Brett. This house then became the first location of Dr. Bellin's hospital, which was simply named General Hospital. Of course, running a hospital requires quite a bit of time and hard work, so the good doctor would require some help to keep things running smoothly. He invited two deaconesses that he knew from Ohio to assist him in the operation of his new venture. Miss Matilda Giese and Miss Delia Scheible gladly accepted the challenge at hand. Robert Dickey was the name of the first patient they treated, which took place on May 6, 1907.

By the following year of 1908, the hospital became incorporated and was already in need of a bigger place. The hospital was then moved to a larger home located on the corner of Lawe and Webster Avenue. Several changes took place during the second year of operation. The first

being that Dr. Bellin began renting this new house to the hospital for forty dollars a month and the hospital was renamed Deaconess Sanitarium. Another change that took place is that Dr. Bellin, knowing that there was a real need for qualified and well-trained nurses in the area, started a nursing training program at the hospital. Three students enrolled the first year but only one finished the course. In 1909, Dr Bellin, an innovator in the treatment of his patients, began offering an alternative concept to the treatment of rheumatoid arthritis and other kindred diseases. It involved submerging patients in a bathtub filled with moor mud. Moor mud is a mud that contains over one thousand decomposed plant deposits. It was originally discovered by the ancient Egyptians and Romans for aliment and beauty treatments. It is still recognized and used by both doctors and health spas today for its healing properties.

The hospital continued to grow due to the dedication and hard work of both the good doctor and staff, and, by 1915, the construction of a new building began in the same location as the house had been. This new building was completed and renamed Wisconsin Deaconess Hospital. It opened for business on January 8, 1916. The new hospital had three floors: a surgery room, a full basement and sixty patient rooms. The cost was $60,000 and it was state of the art compared to the humble beginnings of the house that was first used. Three more additions would be added on to the hospital, making it the building you see today.

In 1925 the name was changed to Bellin Memorial Hospital in tribute to Dr. Bellin for his many years of charitable work and service. Even though it seems more logical that Dr. Bellin would haunt his own hospital building, he actually haunts the second building he constructed in 1915. This building is located at 130 East Walnut Street in downtown Green Bay. It was built as a rental and utilized largely by physicians, dentists and other medical professionals. It was the first small skyscraper, north of Milwaukee and the design of the building was credited to an architect by the name of Perry T. Benton. He would utilize a Chicago-style architecture that used a terra cotta coating that covered the brick exterior walls. This style of wall covering was considered extremely elegant and was first used on the Reliance Building in Chicago in 1895. The Bellin Building originally had only seven floors, but the eighth and ninth were added in 1924 and utilized as penthouses. In 1947, the key-

The Bellin Building.
Courtesy of Dale Johnson.

operated elevator was added and remains one of only four of its kind in the United States. One unique feature of the building that cannot be seen above ground is the huge, heavy, steel foundation pilings that help hold the weight of the building. The pilings are more than eighty feet buried under the surface. They are almost as long as the building is tall and the building would surely crumple without them.

The good doctor still seems to be making house calls, even after death. Over the years, many different tenants have reported seeing him throughout the building. Oftentimes, tenants relate seeing Dr. Bellin from the corner of their eyes, and when they turn to look, he's gone. But, sometimes he does show up in plain view. He's described as a man in his late fifties with gray hair, wearing a black suit and tie and having a smile on his face. He's regarded as a positive energy that is welcomed and encouraged to stay. It's also said that he likes to run the elevators up and down.

CLOUD NINE

The name implies a heavenly place but the previous owners say it is more like pure hell. This story involves a building that has been abandoned since 2007. It is located at 2490 Glendale Avenue in the town of Howard, just five miles west of Green Bay. The town of Howard was established in 1835 by the first French settlers. The first school was built and in operation by 1856. The town's original name was Duck Creek due to the overwhelming number of ducks that migrated there every summer. The ducks filled the wide creek that winds its way through the town. The creek was used for a mail route, farming and a mode of travel among the cities. The name of the town was changed to Howard in 1959. The reason for this was to honor Brigadier General Benjamin Howard, who was an officer in the War of 1812.

The first settlers were encouraged to marry the native Menominee tribe Indians, who lived in the area, as a way to adapt them to the French way of living. The children born from these integrated marriages were called French Creoles. The Menominee Indians were friendly in nature and easily adapted to the new ways of the French; however, on occasion they would still incorporate their own style of native justice.

In 1840, the murder of a local medicine man, Skinny Otter, by another Indian named of Pa-sha-ke-sick proved this fact to be true. After the murder, the Menominees passed a death sentence on Pa-sha-ke-sick. In

order to prevent a hasty execution, the white settlers took away the guns of the tribe. This did not prevent the Indian women from taking vengeance. They severely beat Pa-sha-ke-sick to death and displayed his badly battered body for all to see. Eventually some of the more compassionate people dug a grave and buried him in the old Indian burial ground.

The building that is haunted was the town's old railroad depot. The building was many different things throughout the years: a post office, waterbed store and then a refinishing shop. Legend has it that the basement during Prohibition was used for gambling, drinking and as a brothel. It is rumored that John Dillinger frequented the depot on his way through town to visit a local friend's house just down the street. Another story involves a working girl at the brothel who was murdered by a client and buried somewhere on the property.

In the far end of the long building's basement, there is evidence of an old staircase that has been boarded up and covered over. This was possibly the staircase that was used by the men who frequented the establishment to get their sinful pleasures. One day a customer of Cloud Nine Refinishing walked into the building and told the owner Ron that he had a dream about the building the night before. In his dream, he saw a furnace in the basement and in the furnace was a body being burned to hide the evidence of a murder. He also saw the remains of a body being buried in the basement. The customer showed Ron the spot in the basement where he thought the body was. This section of the basement had a dirt floor so Ron decided to dig to see what he could find. Ron discovered part of a man's watch, a sole of a boot and several bones. There was a human-looking jawbone with teeth on it and many of what looked like human rib bones. Ron placed the items in bags and marked the bags with the time and place that they were found. He brought the items to the local authorities but no lab tests were done to see if they were actually human. On a different day, an elderly man told Ron that when he was a child he remembered peeking into the window of the basement. He would see people being tortured, murdered and then burned in a big furnace.

Ron and his employee John have had many varied haunting experiences over the years. John experienced a playful-type haunting by the entities. He would feel a tapping on his shoulders but when he turned around no one was there. He often heard tapping on the walls around him. He started

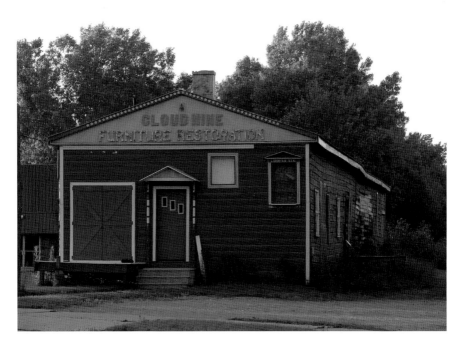

Cloud Nine. *Courtesy of Dale Johnson.*

making a game of it by tapping back in response. The spirit would always tap back the number of times John tapped; when John tapped once the spirit tapped once, then John would tap two times and so did the spirit, and so on. Ron's experiences, on the other hand, were not so pleasant. He was hit, kicked and pushed on a daily basis by unseen forces. Items would be thrown at him and he would hear a voice saying that "it was time to go home now, boy." There was also the sound of a woman laughing in the basement, but when he went to check it out, no one was there. Also in the basement the light bulbs would come unscrewed just enough to prevent them from turning on. Ron also reported seeing a large apparition of a man standing in the back room wearing what looked like a blacksmith outfit. When Ron approached the man, the apparition disappeared. He started to remodel the building and noticed that the haunting was becoming worse. At one point the haunting became so bad that Ron painted gold crosses above every door in the building. Ron decided that he finally had enough. He left work one day and never returned.

MURDER AT THE GOLDEN PHEASANT (LEE'S CANTONESE)

What is now the location of Lee's Cantonese Restaurant, at 2247 University Avenue, was once the home to the Golden Pheasant Inn back in 1930. The address at that time was 2015 Willow Street, and it was part of the town of Preble. This area would later become part of Green Bay's east side.

The Golden Pheasant Inn was best known for its great hamburgers but this was at the height of Prohibition and it also served as a roadhouse to those looking for some bootleg liquor. Both locals and visitors could get the beverage of their choice and partake in a little gambling with either quarter or dime slot machines. Later, it would also become known for one of the most brutal and grotesque murders to take place in Green Bay's history.

On May 19, 1930, Mrs. William De Broux became concerned over the lack of activity next door at the Golden Pheasant. She noticed that the restaurant did not open. She also noticed that throughout the day the milkman, the baker and the public service meter reader came to the restaurant and no one answered the door. She asked her husband to go over there and smell for gas. She was worried that the people inside had possibly been asphyxiated. He did not find any traces of gas, so he did not investigate any further. The next morning when Mrs. De Broux woke up, she became even more fearful when she still did not see any activity

at the restaurant once again. At that time she made the decision to send her young son Martin to investigate. Ten-year-old Martin Verhagen discovered the murders on Tuesday, May 20, at 5:30 a.m. He had climbed on a streetcar and looked in the bedroom window belonging to the owner of the inn. Martin hurried home extremely upset and told his mom that he had seen blood splattered everywhere and two people butchered like chickens. This was not a scene suitable for a child to witness.

The victims were thirty-six-year-old Mr. John Van Veghels, the owner of the Golden Pheasant, and his girlfriend, the beautiful twenty-four-year-old Lucille Birdsall, who was an employee at the inn. They were hacked to death in their bed sometime between 4:00 and 6:00 a.m. on Monday morning, May 19, 1930. The murder weapon is believed to have been a hatchet. John had multiple gashes to his face and head. His wounds were so nasty that they were compared to the blast of buckshot. He possibly never fully woke up to realize what was happening to him. Lucille, however, was not so lucky. Her body had wounds that indicated a horrendous struggle. Her right forearm was sliced several times to the bone. Her face and neck had multiple slashes as well.

The news quickly spread, and by 7:00 a.m. that morning there were more than one hundred people that had gathered outside of the Golden Pheasant. Dozens of looters were stripping souvenirs from inside. This contaminated the scene, making fingerprinting virtually impossible.

The murder weapon was never found and no one was ever charged with the crime. One suspect of the murder was a convict by the name of Thomas Donnelly who claimed that Lucille Birdsall was his girlfriend. While serving time in the Sheboygan County Jail he confessed to committing the murders to a fellow inmate, Bernard Coy, but he was never brought up on charges.

The building was eventually torn down and a strip mall was built in its place. Currently, Lee's Cantonese Restaurant is located in the spot where the Golden Pheasant used to stand. The owners of Lee's Cantonese, Peter and Phillip Lee, purchased the business in 1974. At that time it was called the Don Quixote Supper Club. The owners have reported that there have been strange occurrences witnessed on the property for decades. Some of the activities reported include glasses that danced around on top of the bar and fell over; a rapping that could be heard in

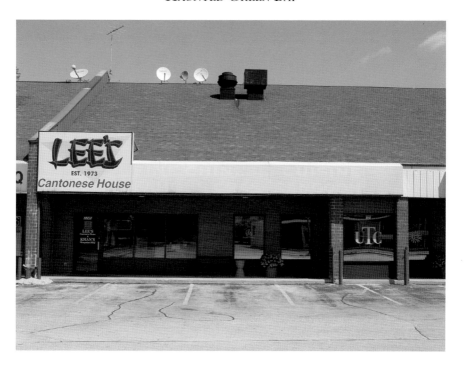

Lee's Cantonese House. *Courtesy of Dale Johnson.*

the room, but no explanation could be found; and one night a woman's voice was heard talking on the telephone but in fact, the line was dead. A local psychic was hired to conduct a séance to try to find some answers to these happenings. During this séance, the psychic used a process referred to as automatic writing. A woman believed to be Lucille Birdsall came through in this writing, stating that her killer was a man named John. He was someone she had met the day before her death and he expressed an interest in her romantically. He was openly disappointed and became ugly about the fact that she was dating the owner and had outright refused his attentions. The Lee brothers remain convinced that the place is haunted, but it doesn't seem to hurt their business; they remain in that location, coexisting with their spirit guests.

UWGB ST. NORBERT'S DORMITORIES

Talk about your school spirit—the only thing that might be scarier than oversleeping on an important test day, is possibly being visited by a ghost in your dorm room. The legendary stories of these haunted dormitories both at University of Wisconsin–Green Bay (UWGB) and St. Norbert College have been passed down for decades. At first these stories seem nothing more than a way for seniors to scare the underclass freshman, and in part this might be true; however, this doesn't explain all the haunting experiences that have been reported by students throughout the years.

This first story involves a dorm room located on the third floor of the Byron Walter Hall at UWGB. Even at first glance you notice that this dorm room is different from the rest. The message board that hangs on the wall outside of the room is filled with frightening warnings and messages written by fellow students. As you enter the room you also notice the ceiling is plastered with these same type messages, although some are only visible with a black light. The stories about the dorm room being haunted began in 1985 with the very first resident. The girl who was occupying the room at that time reported seeing a reflection in the mirror that was mounted to the closet door. The reflection was that of a ghostly looking man. Startled and confused, she turned to see who it was but the apparition of the man disappeared. The spirit is believed to be

the man who donated the trust fund that helped build this dormitory. His name is Byron Walter, and he was a successful businessman in Green Bay.

Mr. Walter was a native of Monroe, Michigan, and, in 1898, after graduating trade school in Milwaukee, he moved to Green Bay. Initially, he was employed by Goltredso Brothers Hardware Company as an office boy. Mr. Walter, though, was a hard worker and was promoted through the years all the way to a buyer for the company. In 1906, he decided to become his own boss after the company he worked for was sold. He formed a partnership in a new hardware and sheet metal company later to be known as the Green Bay Hardware Company, Inc. He worked at this business until he retired in 1953. He was also co-owner of Paper Converting Company, which is still active locally and internationally. In 1954, Mr. Walter died. Although his money helped build the entire dormitory, his spirit has only been reported as being seen in that one particular dorm room. This legend has never lost its spirit, and students—just a few years ago—printed shirts that stated "I survived the haunted dorm room" and wore them around campus.

Then there is Wally, the St. Norbert College spirit who has wandered stately Burke Hall for nearly sixty years. The stories told stem from a mysterious empty elevator shaft that is located at the north side of the building. There are actually two versions of why this shaft is responsible for the haunting in the building. The first version credits an incident that took place in the 1940s. It's been told that during construction of the building, a man hanged himself in the shaft. The second story tells of a construction worker's son who had fallen in the shaft and died. Whatever the reason, the elevator was never installed and the shaft was sealed shut. The spirit haunting Burke Hall has been reported as a little boy wearing a baseball cap who likes to shut off lights and knock out computer screens. There have also been reports of a child's moans coming from the elevator shaft as well as the sound of footsteps behind you even though nobody is there. Of course, Wally, on occasion, has been a convenient excuse for some students not completing assignments on time or oversleeping for class. Either way, Wally is a welcomed student at St. Norbert College and forever will be.

THE HAUNTED HOUSE

Sometimes a mystery is too tough for even a sheriff to solve. This is a story of a house that is located in the historic district of Green Bay's Astor Park neighborhood. Many of the houses located in this area of town are known for they're beauty and stature. The one on South Quincy Street would become known for something quite different. The house is a beautiful two-and-a-half-story, thirteen-room Victorian-style home. It adorns steeply pitched gable roofs with an open gable in the front and a circling veranda. There are original lead stained-glass windows located in the living room, dining room and front parlor rooms and the exterior siding is made of narrow clapboard. Albert H.E. Delaporte, a dry-goods merchant in Green Bay, built the house in 1895. Records show that there was possibly another house that was on the same lot at an earlier time. The house has gone through many significant changes over the years to accommodate the needs of the different families that have lived there. Some of the major alterations include a garage that was added in 1932, and the back porch that was enclosed to create a breakfast room at the end of the kitchen. An old stairway—which once was used by the maids and ran along the south side of the kitchen—was boarded up and then removed in 1974. The original chandeliers were converted from gas to electricity by the Waren family but were later removed by the Froelichs. The front foyer would experience the most significant change of all.

The orientation of the stairs was changed from a wraparound style to a straight up-and-down style. This added more room to the front foyer and an extra room at the top of the stairs.

The reported haunting of this home took place during the time Brown County sheriff Norbert Froelich and his family owned the house. Norbert, his wife, Dee, and seven children lived in the house from 1962 until 1973. The house had some activity taking place from the beginning, but the last four years would be the most active, driving the Froelichs from their home for good. Some of the activities that were reported by the family were unexplainable knocking, footsteps and the mysterious sound of wrinkling paper. Of course, the family wanted to believe that these were pranks, the wind or something else explainable, but there was no logical explanation for the strange occurrences. Around this time, Froelich also received a strange call from a woman that he did not know. The woman claimed that she had a vision about his house and saw a man dressed like a lumberjack that was confined somewhere in the house. She also stated that she heard the sound of wrinkling paper. This call came before Froelich had told anyone about his experiences in the house. Froelich asked his good friend Waren, who had lived at the residence fifty years prior, whether he had experienced any strange happenings while living at the house. Waren said he did not notice anything unusual but did believe that his friend Froelich was telling the truth about his experiences.

One of the first undeniable occurrences happened to Froelich's teenage daughter and her boyfriend while they were sitting in the kitchen. The kitchen had been added at the turn of the century and a paneled wall in the room had once been open and contained a staircase to the second floor. Due to the steps being quite steep and the need for more wall space, Froelich enclosed the stairway. The young couple became startled by a knocking on the other side of the wall inside of the stairway. Assuming that someone was breaking into the house, the young daughter told her father about the knocking and Froelich investigated, but no one was found and nothing was disturbed. The second time that this happened, the sheriff and his two daughters were sitting in the kitchen around 2:00 a.m. when they heard a loud knocking coming from the same wall. The girls screamed and the knocking stopped—but the silence did not last very long. Soon there were sounds of heavy footsteps on the inaccessible

stairway. The girls screamed again and the sounds of footsteps were heard going down to the basement. Froelich was convinced that someone had broken in. He rushed downstairs, expecting to find an intruder but there was no one there. Another incident took place while Sheriff Froelich was alone and his family was sleeping upstairs. He was sitting at his desk working in the study on the first floor late one night. With his back to the staircase he heard the sound of footsteps walking down the steps behind him. He assumed it was his wife, so he called out to her but received no reply. Later that night when he went to bed, he discovered that his wife had been asleep and she was never even near the stairs. Sometimes the family heard footsteps in the upstairs hallway and doors sounded like they were opening and closing. They also heard what sounded like heavy boots pacing on hardwood floors but all of the floors were covered with carpet. There were even occasions when the footsteps were heard everywhere, all at the same time.

The haunting became so frequent and intense that the family became fearful for their own welfare and called a priest in to bless the house. Afterward the priest admitted to Froelich that he didn't think blessing the house would help. The priest was right—blessing the house only made things even worse. Froelich then asked the same priest to perform an exorcism but the priest declined, stating that he was not qualified. Next Froelich decided to contact a spiritualist to find out who was haunting his house. The spiritualist, when in a trance, claimed to see a woman, approximately thirty years old, wearing a long dress and standing at the top of the stairway. It was also suggested that someone might be buried under the kitchen. The family decided to sell the house and move on. Even though Froelich was the sheriff of Brown County, this was one mystery he just could not solve.

THE COTTON HOUSE

This next tale has to do with a haunting by a young woman named Pricilla Cotton. Pricilla was the third child and second daughter of Captain John Winslow Cotton and his wife, Mary. Pricilla was born on Independence Day 1833 and died a short twenty-three years later on June 30, 1856. She died of what was then called consumption, currently known as tuberculosis. She was a pretty girl, although one side of her face was seriously disfigured by a birthmark. She was adored by her family and friends and was considered amiable, gentle and loving. Pricilla and her father were especially close, sharing a love of music and participating in the church choir together. She was married to Colonel James Henry Howe and died after only seven years of marriage, leaving no children.

When it came time that Pricilla was going to die, at her request, she wanted to be moved to her parents' home. She was carried through the streets lying on a cot to a flatboat waiting at the river's edge. Her friends slowly poled the boat upriver until she reached the farm. She finally died in what is now the library in the house that her father had built in the early 1840s. She was buried on that land in a plot that was set aside just for her. It was adorned with stone pillars on the four corners and heavy chains to separate the plot from the rest of the farm. Approximately eighteen months after her untimely death, Pricilla's husband, James, ended up marrying her younger sister Mary.

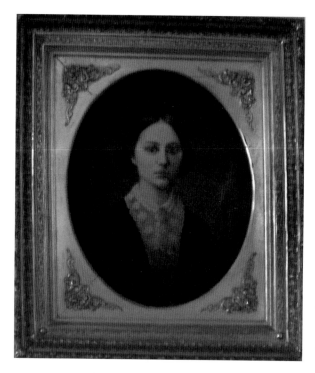

Left: Pricilla Cotton.
Courtesy of the author.

Below: The Cotton House.
Courtesy of the author.

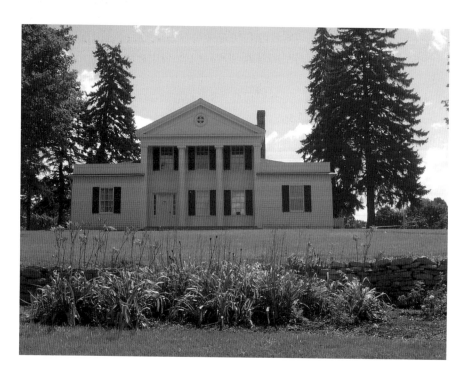

Many years later when the farm was sold, her remains were moved to a cemetery. Her father had later died in the home as well. The home belonged to the family until 1893. It was then sold to J.W. Woodruff, who lived there for ten years until 1903. At that time it was purchased by the Catholic diocese, which wanted to use the land for farming. There were orphans that farmed the land, but the house was not used due to disrepair. Sometime between 1938 and 1941 the house was relocated to its present location and restored by the Brown County Historical Society. It opened as a museum in 1941, and, in 1977, the home became a part of Heritage Hill State Park. It is listed on the National Register of Historical Places. The building design is of a timber frame construction modeled after the Greek-revival style popular from the 1820s to the 1850s.

Throughout the history of the house, there have been many reported sightings of Pricilla Cotton. When employees enter the building, they must greet Pricilla with a "hello" or "good morning," otherwise they run the risk of being tripped by her. If you start talking about Pricilla's husband marrying her sister, a coldness will occur. It is thought that she is not happy about their union. A volunteer reported seeing her rocking in a chair upon coming into the library, but when he looked closer, she disappeared from sight. One year there was a Christmas gathering at the house for employees and a woman was cooking in the kitchen. The cabinet door above her kept opening, even though it was closed with an eye hook. When they closed it, the door kept coming unhooked and opening again several times on its own. When people come into the upstairs front bedroom, they often get an unsettling or queasy feeling. They believe this might be Pricilla's father, John. As long as the Cotton House is safe at Heritage Hill Park, Pricilla and her father can stay and enjoy the home they loved in life.

BIBLIOGRAPHY

American Journeys. "Journey of Jean Nicolet, 1624." American Journeys. www.AmericanJourneys.org (accessed February 2010).

Anderson, Terry. "School Spirit." *Green Bay Press Gazette*. March 5, 2000.

Austin, Lynn. "Haunted Green Bay History." *Green Bay Press Gazette*, November 29, 2009.

Barrillas, Martin. "Saint Death cult draws on pre-Christian roots." *Spero News*. October 31, 2009.

Bellin College. "Bellin College History." Bellin College. www.bellincollege. edu (accessed March 2010).

Boyd, McKim. Interview with the author. June, 2010.

The Broadway Review. Flier, May 1998.

Catholic Herald—Milwaukee, WI. "Robinsonville: A Wisconsin Shrine of Mary." May 23, 1935.

City Directories. Neville Public Museum, Green Bay, WI.

City of Green Bay. "Bay Beach History." City of Green Bay. www. ci.green-bay.wi.us (accessed June 2010).

Classic Encyclopedia. "Amos Adams Lawrence." Classic Encyclopedia. www.1911encyclopedia.org/Amos Adams Lawrence (accessed March 2010).

Commemorative Biographical Record of the Fox Valley Counties of Brown, Outagamie and Winnebago. N.p.: J.H. Beers, 1895.

Cotton, Pricilla. Unpublished memoirs. Brown County Library, Green Bay, WI.

Ellingboe, Mary. "Sheriff Has Haunting Memories." *Green Bay Press Gazette*. October 31, 1975.

E. Morrow Collection. Letters. Neville Public Museum. Green Bay, WI.

Encyclopedia Britannica. "Jean Nicolet (French explorer)." Encyclopedia Britannica. www.britannica.com (accessed May 2010).

Epodunk. "Lawrence." Epodunk. www.epodunk.com (accessed April 2010).

Fort Howard Papers. Archives, Neville Public Museum, Green Bay, WI.

Green Bay Historic Preservation Commission. "Elisha Morrow House–Captains Walk Winery." City of Green Bay. www.ci.green-bay.wi.us (accessed March 2010).

Green Bay Press Gazette. "Couple Slain in Roadhouse." May 20, 1930.

————. "It Beats Them All." July 21, 1899.

————. "Miss Morrow Dies at Age 90." February, 22, 1952.

————. "Morrow Portraits Purchased for Neville Public Museum." July 30, 1952.

————. "Shootings." August 10, 1987.

————. "YMCA Cutting Residential Services by End of Year." September 1, 1988.

Heritage Hill. Flier, n.d.

The Historic Bellin Building. "Bellin Building History." The Historic Bellin Building. www.bellinbuilding.com (accessed March 2010).

Holmes, Fred L. "Quaint Church in Wisconsin Belgian Colony near Green Bay Goal of Many Pilgrimages." *Milwaukee Sentinel*, August 14, 1921.

Howard, Wisconsin. "Howard Village History." Howard, Wisconsin. www.villageofhoward.com (accessed May 2010).

Jacobs, Dennis R. Interview with the author. May, 2010.

Kerin, Lois. "The Memorial Day Murder." *Green Bay Press Gazette*, May 26, 1988.

Lettenberger, Robert J. Interview with the author. June, 2010.

Malmsten, Nina. "Last of YMCA Residents to be Out by Year's End." *Green Bay News Chronicle*, December, 28, 1988.

Milwaukee Journal. "Robinsonville Ready to Receive Crowds on Assumption Day: Altar in Open Air." August, 13, 1922.

————. "Visions lead to pilgrimage." August 3, 1919.

National Railroad Museum. "National Railroad Museum History." National Railroad Museum. www.nationalrrmuseum.org (accessed March 2010).

Occult View. "Santa Muerte, the Grim Reaper Saint." Occult View. www.occultview.com (accessed June 2010).

On Broadway, Inc. Directories. "History of buildings on Broadway Street." Green Bay, WI.

Regina. Interview with the author. April 2009.

Reuters, Aguilar Daniel. "Mexico's Death Cult Protests Shrine Destruction." *USA Today.* www.USAToday.com. April 5, 2009.

Ron (Cloud 9 owner). Interview with the author. October 2008.

Rudolph, Jack. "Green Bay Has Long History." *Green Bay Press Gazette*, August 15, 1964.

"Santa Muerte: The New God in Town." *Time.* www.time.com (accessed on May 2010).

Schuch, Ed and Erma. Interview transcripts. On Broadway.Inc., n.d.

Shannon, Harold T.I. "Thousands Will Join 60th Pilgrimage to Robinsonville Shrine on Sunday." *Green Bay Press Gazette*, August, 13, 1925.

Shrine of Our Lady of Good Help. "Sister Adele Brise and the Brise Family" Shrine of Our Lady of Good Help. www.shrineofourladyofgoodhelp.com (accessed April 2010).

Srubas, Paul. "Man Held in YMCA Killings." *Green Bay Press Gazette*, August 8, 1987.

Stahl, Lynn. Interview with the author. June 2010.

Titletown Brewing Company Anniversary and Historical Celebration. Flier, n.d.

University of Wisconsin–Green Bay. "Byron Walter Hall." University of Wisconsin–Green Bay. www.UWGB.edu (accessed April 2010).

Walker, S. Lynne. "Skeleton Force." *The San Diego Union Tribune.* July 1, 2004.

Wikipedia. "Amos Adams Lawrence." Wikipedia. www.wikipedia.org. (accessed March 2010).

————. "Dwight D. Eisenhower." Wikipedia. www.wikipedia.org (accessed June 2010).

————. "Jean Nicolet." Wikipedia. www.wikipedia.org (accessed May 2010).

————. "Lawrence Brown County Wisconsin." Wikipedia. www. wikipedia.org (accessed April 2010).

————. "Santa Muerte." Wikipedia. www.wikipedia.org (accessed May 2010).

————. "Village Of Howard Wisconsin." Wikipedia. www.wikipedia. org (accessed May 2010).

ABOUT THE AUTHOR

Tim Freiss is the owner and operator of Green Bay Ghost Tours in Green Bay, Wisconsin.

Visit us at

www.historypress.net